IMAGES
of America

MARION

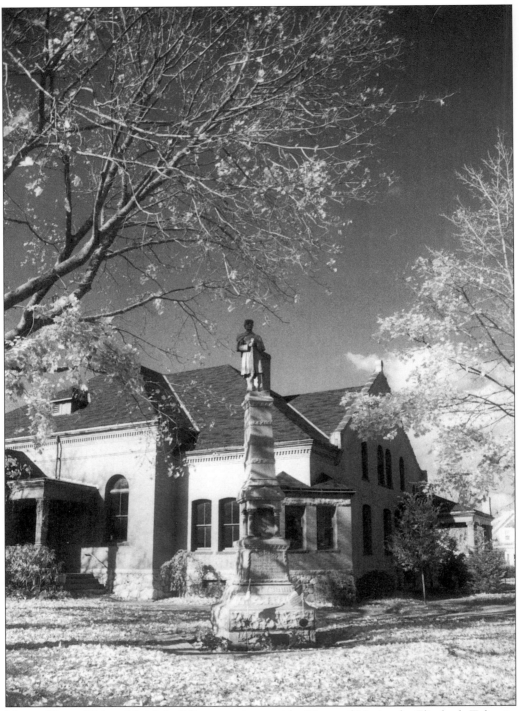

MUSIC HALL. This red brick building was given to the Town of Marion by Elizabeth Taber in 1891. The Soldier's Monument was dedicated in 1894 to local citizens who lost their lives in the American Revolution, the War of 1812, and the Civil War.

IMAGES
of *America*

MARION

Judith Westlund Rosbe

ARCADIA

First published in 2000.

Published by Arcadia Publishing,
an imprint of Tempus Publishing, Inc.
2 Cumberland Street
Charleston, SC 29401

Printed in Great Britain.

Library of Congress Catalog Card Number: Applied for.

For all general information contact Arcadia Publishing at:
Telephone 843-853-2070
Fax 843-853-0044
E-Mail sales@arcadiapublishing.com

For customer service and orders:
Toll-Free 1-888-313-2665

Visit us on the internet at http://www.arcadiaimages.com

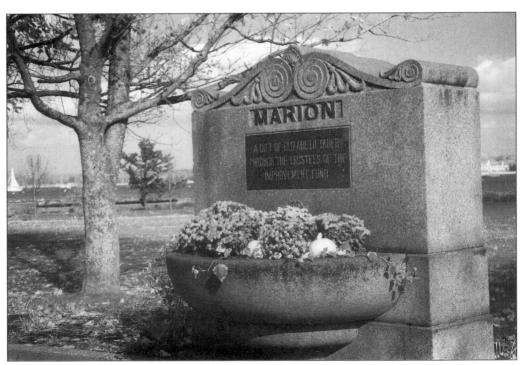

WATERING TROUGH. Located at the edge of Waterfront Park in the heart of Marion's town center is a granite tribute to local benefactress, Elizabeth Taber, who is admired for her extraordinary generosity to the Town of Marion.

CONTENTS

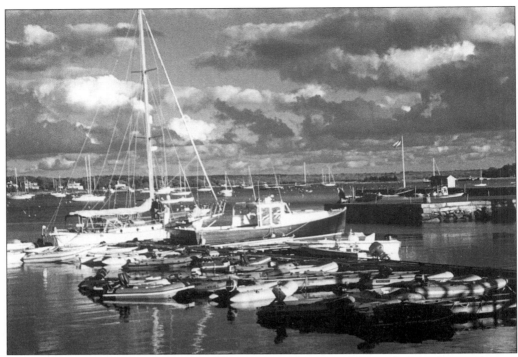

MARION HARBOR. The predictable afternoon sea breezes of Buzzards Bay draw sailors to Marion's picturesque harbor.

For Charles Robert Vrattos,
my first grandchild,
born September 8, 1999.

INTRODUCTION

Marion is a small town in southeastern Massachusetts on the shores of Buzzards Bay. Its full-time population is approximately 5,000 people, although that number greatly increases in the summer.

Marion was originally called Sippican for the Native Americans who lived here. These Native Americans were members of the Wampanoag tribe under the leadership of Chief Massasoit. In 1678, 29 Pilgrim families left Plymouth, Massachusetts, and settled on Hermitage Road near Minister's Rock in Sippican. Since Sippican's waters were rich in oysters, the early settlers renamed this area Rochester after the English town that was also known for its oysters. At that time, Rochester encompassed what is today Marion, Mattapoisett, Rochester, and parts of Wareham.

Around the time of the Revolutionary War, Marion had a thriving salt industry, which produced salt made from evaporated saltwater. This industry thrived because salt was so necessary for the preservation and curing of fish. When Britain levied a tax on salt, Marion set up elaborate windmills and troughs to evaporate seawater. This industry thrived in Marion until salt was discovered in Pennsylvania around 1815.

Later, Marion became a place where many sea captains lived during the whaling era. At one time, 87 captains lived in Marion, which became a small and thriving seacoast town. Ships docked in Marion also carried pine logs from Rochester to the southern United States. In fact, Marion received its name at the suggestion of these sea captions, who were enthralled with General Francis Marion (called the "Swamp Fox"). Marion was a Revolutionary War hero from South Carolina who led a very successful guerrilla war against the British.

In 1876, Elizabeth Pitcher Taber, the town's benefactress, established Tabor Academy in Marion, which capitalized on its waterfront location for its students. Tabor Academy's sailing and crew teams consistently attain national recognition today.

By the 1880s, Marion was becoming a nationally known resort for the rich and famous, and it remained such for many years. This was to be known as the golden age of Marion. Author Henry James, in his novel *The Bostonians*, brought his hero to Marion, which became a popular summer resort because if its predictable afternoon sea breezes. Bessy Harwood, daughter of the Civil War admiral Andrew A. Harwood, talked her friend Richard Watson Gilder, the editor of *Century Magazine* from 1881 to 1909, to come to Marion with his family to relax in the summer. Because of Gilder, many notable artists, writers, and intellectuals also summered in Marion. His friends included President and Mrs. Grover Cleveland; journalist Richard Harding Davis;

authors William Dean Howells, Henry James, Ralph Waldo Emerson, and Frank Stockton; Lincoln biographers John C. Nicholay and John Hay; actors Joseph Jefferson and Ethyl Barrymore; sculptor Augustus St. Gaudens; illustrator Charles Dana Gibson; naturalist Louis Aggaziz; Arctic explorer General Adolphus Greeley; the Episcopal Reverends Phillips and John Brooks; Polish Actress Helen Modjeska, Japanese diplomat Okakeura Kakuzo and Stanford White, partner in the architectural firm of McKim, Mead, and White. Stanford White designed the fireplace in the Old Stone Studio, which was purchased by Richard Watson Gilder for his artist wife, Helena deKay Gilder; a salon of famous artists would gather there in the evenings.

Because Marion is "off the beaten track," it was not discovered by real estate developers. Consequently, its rich supply of historic buildings remains today. Marion possesses the smallest home that architect Henry Hobson Richardson ever designed and built. He is noted for large Romanesque buildings, most notably the Trinity church in Boston. The Reverend Percy Browne bet Richardson that he could not build a house for $2,500 and Richardson won the bet.

Today, Marion is also a popular yachting port and hosts the biannual Marion-to-Bermuda race and other national boat racing events. There is a long waiting list for yachtsmen and women who want moorings in Marion Harbor.

This book is based on a 1998 architectural survey of Marion conducted by Edward W. Gordon, an architectural historian and consultant for the Sippican Historical Society and the Massachusetts Historical Commission. The Sippican Historical Society and the Massachusetts Historical Commission each funded one-half of the cost of the survey. All of the photographs of the buildings in this book were taken by Steven Gyurina, who worked for Mr. Gordon and me. I want to thank Mr. Gordon and Mr. Gyurina for all their hard work.

I wish to thank especially Tess Cederholm, a Sippican Historical Society director, who made introductions to the people at the Massachusetts Historical Commission and encouraged the Sippican Historical Society to apply for funding. She is both a librarian and knowledgeable architectural historian; previously, she catalogued architectural drawings at the Boston Public Library. Finally, I want to thank my husband, Bob Rosbe, for his encouragement in all phases of this project.

While I have attempted to be diligent in my research, I take responsibility for all errors in this book. I hope that someone will continue this project, so that all the historic buildings in Marion will be researched in the future.

—Judith Westlund Rosbe
Director and past president
of the Sippican Historical Society

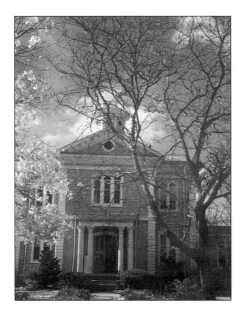

ELIZABETH TABER LIBRARY AND MUSEUM OF NATURAL HISTORY. This building was constructed in 1871–1872 with funds donated by Elizabeth Taber as "a testimonial of my esteem and kind regards for the Library Association and Natural History Society and for the inhabitants of Marion, generally."

One

OLD LANDING

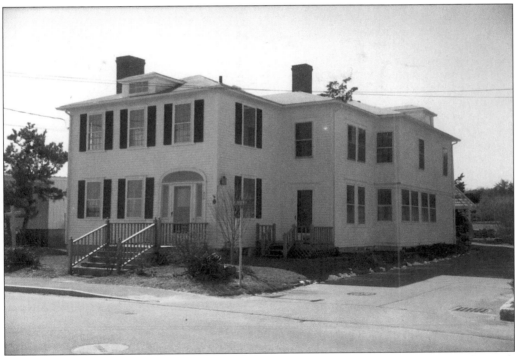

294 FRONT STREET. The dwelling at 294 Front Street was built in the first quarter of the 19th century for Hezekiah and Mary Mendell. The Mendell family in Marion dates back to the Revolutionary War, when Pvt. Daniel Mendell and Cpl. Church Mendell served. From 1850 to 1880, William C. Mendell, master mariner and a veteran of the Union Navy, owned this house. By 1890, Hosea Morril Knowlton, the prosecuting attorney in the Lizzie Borden trial at Fall River and later the attorney general of Massachusetts, rented this house for many years. His wife, Sylvia, was the founder of the Marion Visiting Nurse Association.

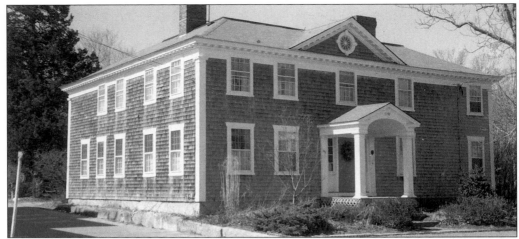

296 FRONT STREET. Built in 1797, 296 Front Street is a late Georgian- and Federal-style house built for Ward Parker Delano, the leading merchant in Old Landing during the first half of the 19th century. His store was located directly across the street on the site of what is now Burr's Boat Yard. For many years, the Pythagorean Lodge was housed above his general store. During the late 19th century, his store was operated by Charles Henry Delano, who supplied the neighborhood with necessities and had the mail delivered there once a day from the lower village. In 1879, Ann Delano owned this house, while the W.P. Delano estate owned it by 1903.

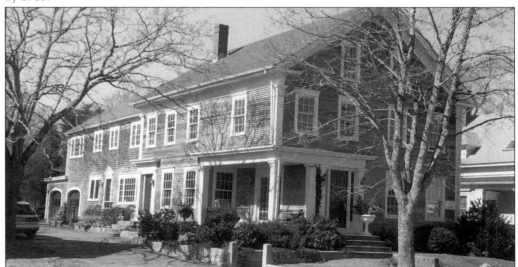

304 FRONT STREET. The home at 304 Front Street, in the Old Landing area of Marion, was built in 1859 for shipbuilder David Hathaway. It ranks among the town's most substantial Greek Revival residences and illustrates not only Marion's mid-19th-century maritime prosperity, but also Old Landing's status as the home of sea captains. Hathaway built coastal schooners at his wharf. These schooners were an important part of Marion's economy. The coastal schooners carried salt to towns between Nova Scotia and the Carolinas. In fact, the operators of Marion's coastal schooners named the town after Revolutionary War hero Francis Marion (known by the nickname "Swamp Fox") of South Carolina, whose exploits in that area became well known to Marion mariners.

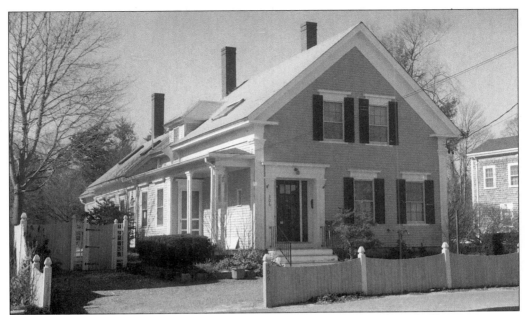

306 FRONT STREET. The dwelling at 306 Front Street is a one-and-one-half-story, cottage-scale Greek Revival residence with Classical elements. Built in the 1840s, this was the residence of the Joseph Blankinship family until 1875. Blankinship was a master mariner and past master of the Pythagorean Lodge. Blankinships had lived in Marion since at least the mid-18th century, intermarrying with the Nyes and living at Charles Neck, later called Converse Point. From the late 1870s until 1910, this house was owned by Charles D. Hall, a carpenter and constable of Marion. Hall's widow, Henrietta, lived here until 1920.

309 FRONT STREET. Built *c.* 1855, the home at 309 Front Street is a Greek Revival cottage, currently part of Burr's Boat Yard. During the second half of the 19th century, it was owned by Leonard Bolles, master mariner. By 1903, Leonard Bolles, a laborer, lived here. Also in residence here during the first quarter of the 20th century was Sarah E. Leonard, the widow of Seth Leonard. Burr's Boat Yard was established after the hurricane of 1938 on the site of the storm-destroyed Watts Boat House.

310 FRONT STREET. Built around the time of the Revolutionary War, the Capt. James Luce House at 310 Front Street is a relatively rare example of a "pure" Federal-style residence in Marion. By the early 1800s, Old Landing was included as a stop on a stagecoach route linking Wareham with Wharf Village. This house served travelers as a stopover and was known as the Norton Tavern. From the 1810s, until at least the first decade of the 20th century, this house was owned by Luces. Beginning in 1816, Captain James and Dolly Luce lived here, followed by Bessie D. Luce in the late 19th century and Henry C. Luce, a clerk, in the early 1900s.

314 FRONT STREET. The Capt. Henry Delano House at 314 Front Street presides over a front yard enclosed by a simple mid-19th-century cast-iron fence in the heart of the Old Landing area. This house was built for Capt. Henry Delano in 1837. The distinctive attic window also appears on the Reverend Leander Cobb House at 28 South Street and represents the only other residence with this Greek Revival-style window in Marion. This house was owned by Laura J. Gibbs from 1900 until her death on August 12, 1925.

317 Front Street. The building at 317 Front Street is an early example of the Greek Revival style in Marion, probably built in the 1830s. The 1855 Marion map shows that this home belonged to Peleg Blankinship and, by 1879, to Pardon Tripp, a master mariner. By 1903, this house was the summer residence of Mr. and Mrs. Alvin F. Besse of New York. The Besses lived here until 1910.

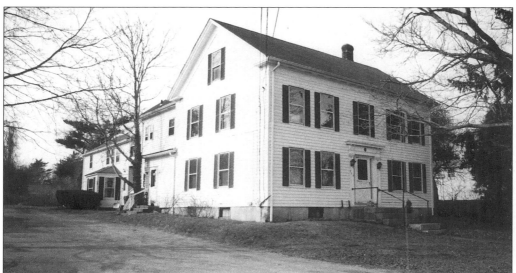

324 Front Street. Begun in 1800, achieving its present Greek Revival and Italianate appearance by 1850, the building at 324 Front Street was the home of one of the town's most colorful mariners. Capt. Obed Delano was a "whale man" who went to sea at an early age on the vessel *Hopeton*. He sailed from New Bedford and later served as a member of the Massachusetts legislature. He was one of the Old Landing seafarers who shaped town policies until the power base shifted to Wharf Village during the 1870s. By 1903, Obed's widow, Verona Delano, lived here with her son, Capt. Stephen O. Delano, who died in 1925.

13

325 FRONT STREET. The home at 325 Front Street may date to the early 18th century. Its lean-to profile suggests that it is one of the earlier dwellings in the Old Landing area. The earliest identifiable owner is A.M. Bassett, who owned this house in 1855. By 1879, Mary Penniman lived here. By 1903, William R. Gifford—the owner of Gifford's Livery Stable across from the depot at Front and Spring Streets—lived here. His widow, Adele, lived here until at least the mid-1920s.

345 FRONT STREET. The stylish and substantial Italianate building at 345 Front Street was built in 1846 for Capt. Stephen Hadley. He and his brother, Capt. Emerson Hadley (who lived across the street, where a convenience store stands today), were captains in the international, rather than coastal trade. Capt. Stephen Hadley resided here until at least 1880. Arctic explorer Adolphus Greeley and his family rented this house and invited Frances Cleveland to visit during the last year of her husband's first term as President. She persuaded her husband to come back to Marion the next summer. By 1903, Hadley's widow, Sarah L., and daughter, Ann E. Hadley, lived here. This property passed from Hadley ownership by 1920.

Two

WHARF VILLAGE

28 BRIGGS LANE. Running parallel to Main Street, Briggs Lane, formerly Back Street, is a narrow way extending from Mill Street (Route 6) to Pleasant Street. Before Main Street was extended from Pleasant to Mill Street in 1829, Briggs Lane was the old road connecting the southern section of Wharf Village with Main Street. Much of the charm of the south side of this street depends on the presence of an early- to mid-19th-century dwelling at 28 Briggs Lane. This house may have been moved here from another location, as it does not appear on the 1855 or 1879 Marion maps. By the early 1900s, this house is shown on its present lot. At that time, it was owned by Seth H. Briggs, a "jobber."

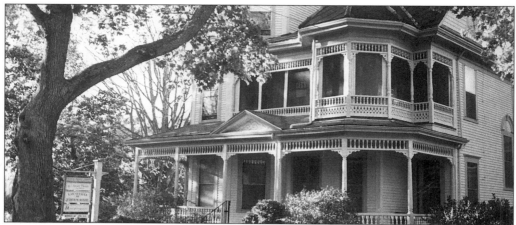

9 COTTAGE STREET. Set out during the 1880s, Cottage Street runs eastward from Spring Street to Front Street. The building at 9 Cottage Street is an example of the Queen Anne style of architecture. This house was built in the 1890s for Dr. A.W. Rice, who had his office on the first floor. He lived with his family on the second and third floors. This charming house has all of its interior woodwork preserved. During the 1870s, the lot on which this home was built was part of a large parcel owned by Marion grocer A.J. Hadley. This home was later owned by Viggo Peterson, who sold Peterson's Ice Cream from the rear of this house.

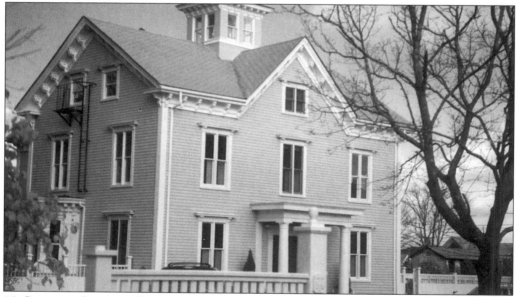

13 COTTAGE STREET. This house was built in 1880 as Taber Hall to house Tabor Academy's first principal, Clark P. Howland. Mrs. Taber, the founder of the school, called the school, "Tabor" after Mount Tabor in the Bible, instead of naming it after herself. Thirteen Cottage Street is an example of the Italianate style of architecture, which was popular in America between the late 1840s and early 1880s. Mr. Howland, a graduate of Yale University, lived on the first floor, while Mrs. Elizabeth P. Taber lived in two rooms on the second floor. Born in Marion in 1791, Elizabeth Pitcher married Stephen Taber, who left her a considerable fortune upon his death in 1862. She then became Marion's most important benefactress and lived in Taber Hall until her death in 1888 at the age of 97.

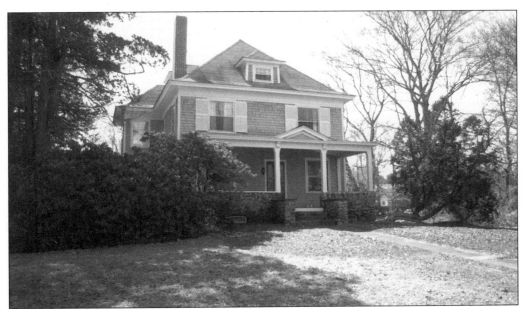

20 COTTAGE STREET. Situated at the southwest corner of Cottage and School Streets, 20 Cottage Street is a Queen Anne and Colonial Revival residence built for Florence and Walton S. Delano during the 1890s. He commuted from Marion to Wareham, where he was employed by A.S. Guerney and Company, dealers in coal, grain, and flour. The Delanos lived here until at least the mid-1920s.

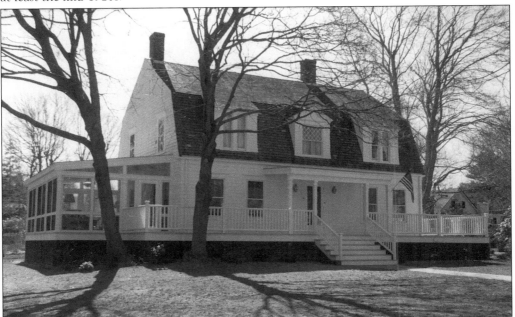

28 COTTAGE STREET. The handsome, substantial home at 28 Cottage Street blends characteristics of the Queen Anne, Shingle, and Colonial Revival styles. Enclosed by a broad gambrel roof, the original open center porch exhibits chamfered posts. This home was built for Harvey W. Everest, a real estate agent.

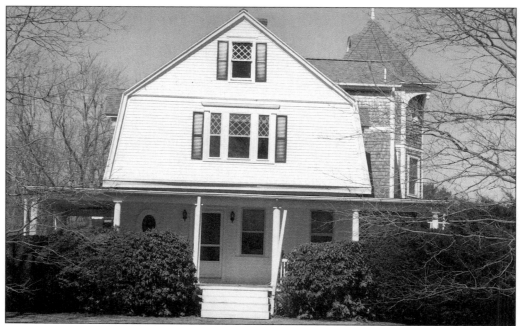

29 COTTAGE STREET. The clapboard- and wooden shingle-clad William Kelly House at 29 Cottage Street is an example of a towered Queen Anne house from *c.* 1890s. It also incorporates the Shingle (gambrel profiles), Colonial Revival (porch elements), and Palladian (attic window) styles. Capt. William Kelly lived here until *c.* 1905.

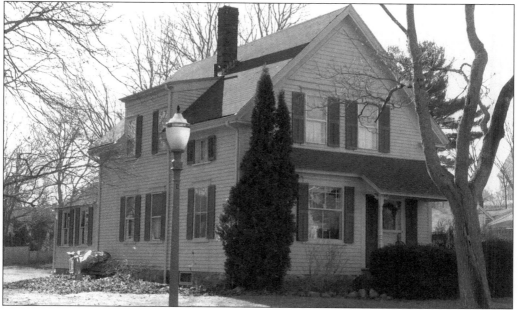

32 COTTAGE STREET. The Queen Anne house at 32 Cottage Street displays the compact, boxy, and rectangular form that was characteristic of houses built in the early 19th century. It was built for Emma and George F. Handy. He was a painter and paperhanger. The Handy family owned this house until at least the 1920s.

18

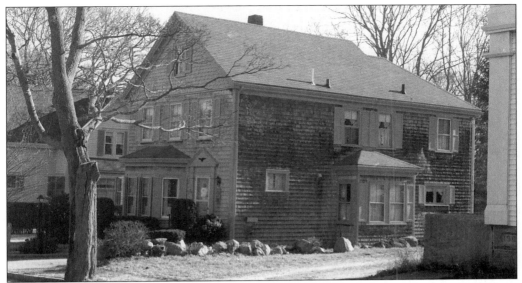

36 COTTAGE STREET. The dwelling at 36 Cottage Street was built for painter Russell G. Grey. The son of Capt. Russell Grey, he grew up in the home at 12 South Street. The Greys resided at 36 Cottage Street until 1920. Interestingly, a photograph of this house was included along with images of more substantial Shingle-style residences in E.G. Perry's early 1900s souvenir guidebook *A Trip Around Buzzard's Bay.*

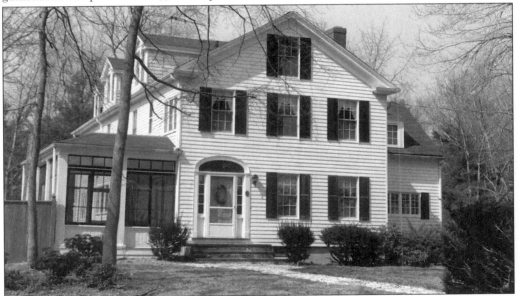

84 FRONT STREET. Of all the town center's streets, Front Street possesses the most varied collection of buildings. The home at 84 Front Street was originally located on the southwest corner of Holmes and Water Streets and was moved to its current location in the early 1960s to serve as Tabor Academy housing. One portion of this house was built for Ebenezer Holmes *c.* 1783 and enlarged in the mid-19th century. By 1903, this house was owned by Mrs. M.A. Knowlton. In 1961, Mrs. Otto Braitmayer, the last owner of the house at its Water Street location, gave the house to Tabor Academy.

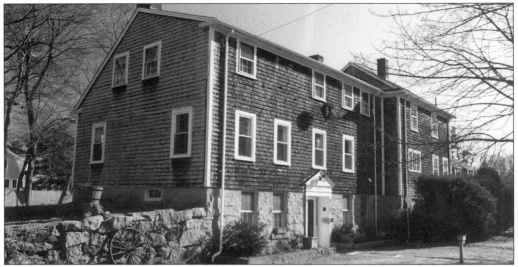

113 FRONT STREET. The "Old Parsonage," located at 113 Front Street, was built in 1813 by Capt. John Pitcher, brother of Elizabeth Taber. The side of the building that faces Front Street is actually the back of the original dwelling. It is now St. Rita's Rectory. Across the street from Capt. John Pitcher's home was a large pasture where his sheep and cows grazed. He used to hang a ship's bell from a Swedish ship on the branch of an oak tree and rang it every evening at 9 p.m. as a curfew bell. The bell is now located in the Marion Natural History Museum. When Capt. Pitcher died, he left his house to the Congregational Church, which used it as a Parsonage for many years.

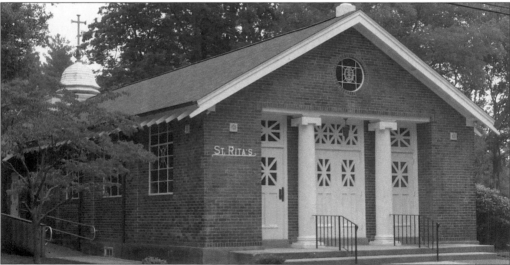

115 FRONT STREET. Built in 1916, St. Rita's Catholic Church is at 115 Front Street on the corner of Front and Vine Streets. It is a handsome rectangular, one-story, gable-roofed, and brick- and wood-trimmed building. Representing an interesting mix of the Classical Revival and Craftsman styles, the Front Street side of the building features three entrances that are recessed behind an entrance porch with columns. Its side walls are pierced by clear and stained glass windows, and a small dome cupola bearing a cross rises from the eastern end of the roof. The exposed rafters of the eaves illustrate the Craftsman style.

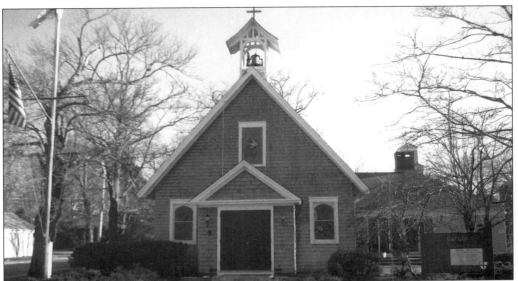

124 FRONT STREET. St. Gabriel's Episcopal church at 124 Front Street has been radically altered since its beginning as a Greek Revival school building. It was built in 1847 as Sippican Academy, a private school for the daughters of whaling captains. In 1860, the upper floor housed the town library and was rented to the Sons of Temperance one evening every week at a rate of 20¢ per evening. In 1874, the Sippican Seminary was bought at public auction for $700 by Andrew A. Harwood of the U.S. Navy for the purpose of divine worship. Over the years, the chapel was gradually transformed into a one-and-one-half-story Carpenter Gothic building. The beautiful stained glass windows were designed by the renowned artisan, Charles J. Connick, whose studio was located in Boston.

140 FRONT STREET. The Congregational Meetinghouse (now the Marion general store) at 140 Front Street was built between 1794 and 1799, during the Federal period. In the 1840s, the Greek Revival style was employed to update this building, which marks the southern entrance to the town center's small commercial district. The Congregational Meetinghouse, more than any other building, symbolized Wharf Village as an important new focus for the spiritual, commercial, and social life in Marion. It also represented the first step toward independence from its mother town of Rochester. For the first time since the early 1700s, the town folk did not have to travel to Rochester center to partake in religious services.

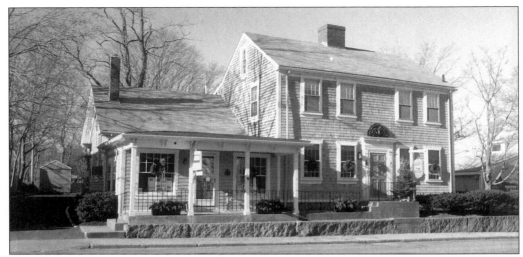

152 FRONT STREET. Another indication of Wharf Village's rise as an important commercial and residential center is the former Handy's Tavern at 152 Front Street. Built in 1812, it was a popular gathering place for mariners after completing a day's work on the waterfront or celebrating the successful conclusion of a voyage. Perhaps more importantly, it was a stop on the Plymouth-to-New Bedford stagecoach route. The coming of the railroad to Marion in 1855 effectively terminated operations at Handy's Tavern. By that time, it was owned by former whaling captain Ben Handy, who commanded a famous whaler called the *Admiral Blake*.

160 FRONT STREET. The building at 160 Front Street was built with the timbers of a salt works that was destroyed in the 1815 hurricane. This Federal and Greek Revival building was owned by J.S. Gorham in 1855 and by the C.H. Damon estate by the early 1900s. In 1931, this house was open to tourists as a typical New England home. A *Wareham Courier* article dated July 17, 1931 explains that "the Rosamond Inn at Cottage and Front Streets, Marion, has thrown open its doors to tourist travel and to those who have read of New England hospitality. The homey features of the abode and the traditions handed down from the early settlers will enjoy this hostelry's outstanding features such as delicious meals and large comfortable and unusually pleasant rooms."

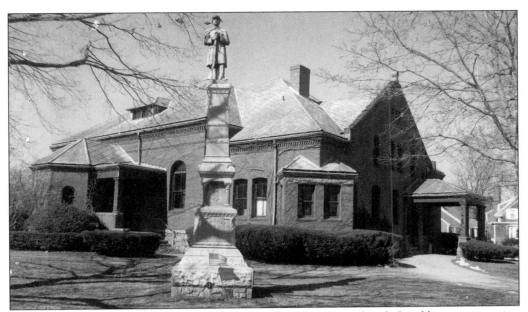

164 FRONT STREET. Constructed of red brick with terra cotta and rock-faced brownstone trim, the Queen Anne-style Music Hall at 164 Front Street was designed by Boston architect William Gibbons Preston in 1891. A Soldier's Monument made of cast iron is situated in front of the Music Hall. It was dedicated in 1894 as a tribute to local citizens who lost their lives in the American Revolution, the War of 1812, and the Civil War. The monument lists the battles in which Marion soldiers bravely served: Fort Fisher, Gettysburg, Cedar Creek and Lexington. An inscription reads: "Marion erects this monument to the Brave Defenders of the Union in Grateful Remembrance of their Valor and Devotion."

168 FRONT STREET. Built around 1860, the Greek Revival residence at 168 Front Street probably represents the work of its first owner, Seth G. Mendell, a carpenter. By the early 1900s, this home was owned by Isaac E. Hiller, a proprietor of the Hiller's Livery Stable, Coal and Lumberyard.

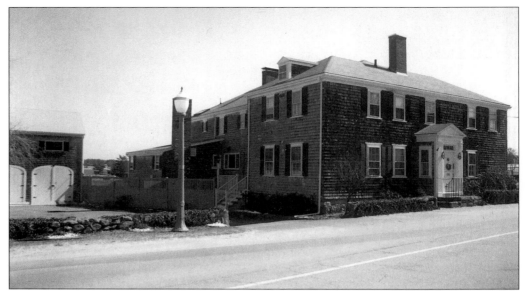

173 FRONT STREET. This Late Federal-style home was built *c.* 1830 for B.R. Keith. The cellar in this home was used to conceal runaway slaves.

182 FRONT STREET. Situated near the northeastern edge of the Wharf Village area is a well-preserved 1790 cape at 182 Front Street, which has been lovingly preserved by the Ryder family. Walter Hellier owned this house at one time. This center entrance residence has a small, projecting, and enclosed entrance accessed by several heavy granite steps. Simply framed by narrow vertical and horizontal boards, its front door has a three-pane transom over it. Rising from the center of the roof is a substantial chimney.

192 FRONT STREET. Marion is fortunate to have a home designed by one of America's most famous architects, Henry Hobson Richardson, who is noted for designing the Trinity church in Boston. This Shingle-style home at 192 Front Street was built in the fall of 1881 for Rev. Percy Browne (1839–1901) as a "country house." This was one of the smallest and least expensive structures that Richardson ever built. In fact, Richardson designed the house on a wager, when Reverend Browne bet that Richardson could not design a small house for $2,500. The Shingle style of architecture is a uniquely American style in which the building is unified by a skin of wood shingles.

13 HILLER STREET. Extending eastward from Front Street and turning southward to meet Main Street, Hiller Street is noteworthy as a side street with a gritty appearance. It was named Hiller Street around 1900 after the enterprising family that owned most of the residences and utilitarian structures bordering this back street. The structure at 13 Hiller Street is a wood shingle Queen Anne building that may have been built as a stable. An off-center hayloft opening appears at the second story beneath the eaves. Built *c.* 1880–1890, this building was owned by Theodore J. Tripp, a baker, by the early 1900s.

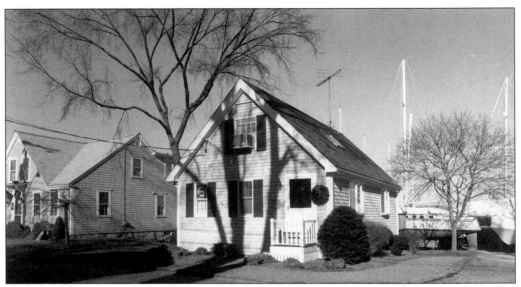

15 HILLER STREET. The oldest structure on this thoroughfare may be the former blacksmith shop at 15 Hiller Street. Adapted as a private residence *c.* 1910–1920, this wooden structure is labeled "Blacksmith Shop" on an 1855 Marion map. The 1879 map indicates that this lot encompassed a stable as well as a blacksmith shop. Rufus S. Briggs operated a blacksmith shop in this building as late as 1903. The current sign on this renovated structure reads "ice house," referring to its usage during the 1930s and 1940s.

17 HILLER STREET. The cottage located at 17 Hiller Street was built in 1880 for Robert B. Hiller in the late Italianate style. This house is located next to the former Robert B. Hiller Livery Stable, Coal and Lumberyard. Beginning in the 1890s, the Hiller Brothers provided horse-drawn vehicles to summer visitors registered at the Sippican House Hotel and ferried the guests between the hotel and depot. By 1916, Hiller's livery stable had been converted into a garage, and later the Hillers became pioneers in the local cranberry industry.

2 MAIN STREET. Of all the area's thoroughfares, the densely built-up Main Street has the most picturesquely antique appearance. Main Street west of School Street was set out in 1829. The late Georgian residence at 2 Main Street is known as the "Two Captains' House" for its owners, Capt. Elisha E. Luce and Capt. Noble E. Bates. Captain Luce moved into this house shortly after his marriage to Jane Hiller, daughter of Timothy Hiller. (The latter Hiller grew up in a house at the corner of South and Water Streets that was later enlarged to become the Bay View House and the Sippican Hotel.) Luce's best-known ship was the *Persia*, which made numerous profitable trade missions to the Far East. This house was also the birthplace of the Universalist Church in Marion. In the early 1830s, Universalists met in Captain Bates' part of the house. Bates owned Bates Wharf (later Union Wharf) at the foot of Main Street.

3 MAIN STREET. The late Georgian-style residence at 3 Main Street occupies the site of the 1760 J.C. Luce House. Conveniently located near Long Wharf, this 1806 building originally contained A.J. Hadley's Store, where ships were outfitted for voyages in the eastern half of the first story. The western side housed the first post office in Marion. Clothing was made on the second floor, and sails were made on the third floor in the early 19th century. By 1855, this house was owned by Sumner Ryder, who served as the Town Clerk (1856–1858) and later joined the Union Army during the Civil War. By 1879, this house was owned by J. Abbott, and during the early 20th century by Miss Sarah W. Harwood.

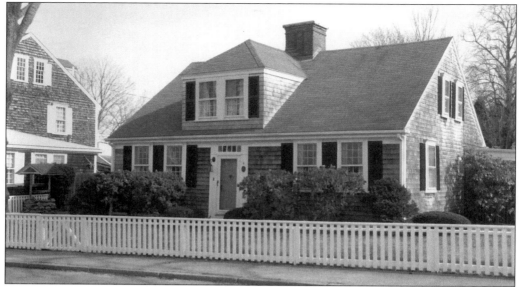

6 MAIN STREET. The charming cape at 6 Main Street is said to date to the early 1880s. Its earliest known owner is "ships caulker" Lucius L. Kelley. According to the 1873 Rochester directory, Lucius and Henry Kelley were the town's only practitioners of this trade. Later owners included W. Pomeroy (1879) and M. Cushing (early 1900s).

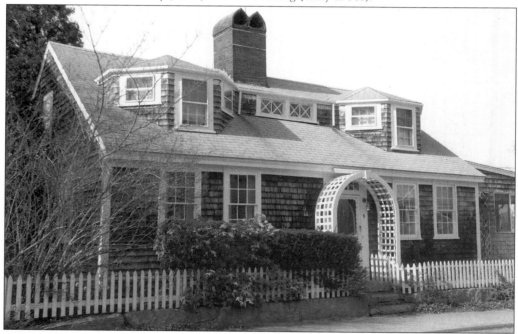

9 MAIN STREET. The cape at 9 Main Street was built in 1780. The narrow front yard is enclosed by a granite block border, picket fence, and shrubbery. This home was Richard Harding Davis's workshop at one time and Admiral Byrd is known to have summered here. President Franklin Delano Roosevelt stayed in this house when he visited his friend, Dr. William McDonald of 99 Water Street, who treated the president for polio.

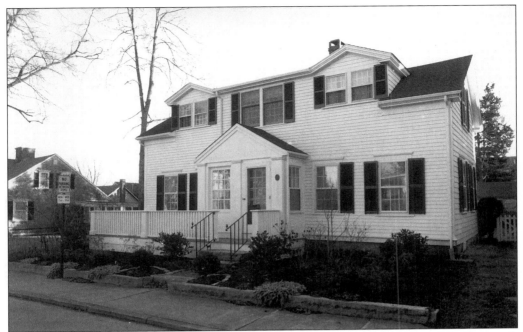

10 MAIN STREET. Reportedly built *c.* 1820, 10 Main Street was the location of Eli Sherman's shoemaker shop. During the late 19th and early 20th centuries, this house was owned by Charles L. Church. Employed as a gardener during the early 1900s, he and his partner, Lester E. Stowell, operated Church and Stowell's Hardware and Plumbing Company by 1907.

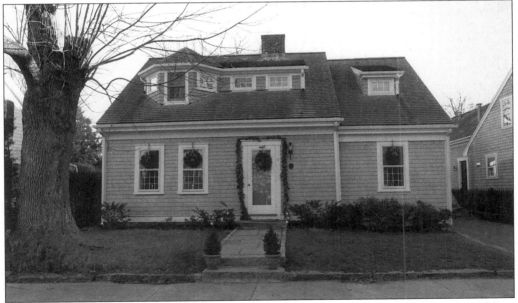

12 MAIN STREET. Built in 1820 by a member of the Blankinship family, the home at 12 Main Street represents a small, shingled ten-footer common in the early 19th century. At the turn of the century, Richard Harding Davis, the famous war correspondent, rented this home and used it as a club (the *Fin de Siecle* Club), where some of the men in town could meet.

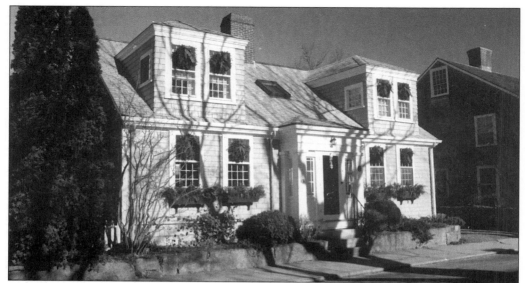

13 MAIN STREET. Erected in 1790, 13 Main Street was owned by J. Blankinship in 1855. By the early 1900s, Henry M. Prichard, an accountant, lived here. Born in New York City on July 31, 1845, Prichard enlisted in the 25th Massachusetts volunteer infantry of the Civil War and was part of the Burnside Expedition. According to his obituary in the March 13, 1893 *Wareham Courier*, "he was wounded so seriously at the Battle of Cold Spring Harbor that he never fully recovered." An ardent devotee of canoeing, Prichard retired to Marion. His widow, Alice, and his daughter, Abbie, lived here until the mid-1920s.

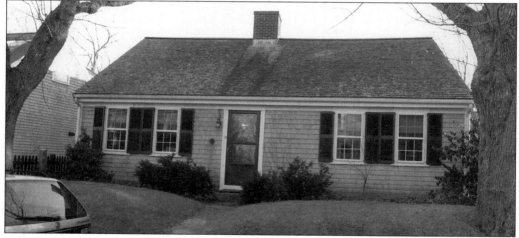

14 MAIN STREET. Built in 1760, the Cape Cod cottage at 14 Main Street was built for the Bates family. Behind this house is a small one-room schoolhouse where Elizabeth Pitcher Taber taught before her marriage in 1823. At one time, Miss Roberta Bates and her sister, Nancy Bates Crowell, kept a calico and notions shop in part of this house. At the turn of the century, noted artist and magazine illustrator Charles Dana Gibson lived here. He was the creator of the famous Gibson Girl, which helped to define female fashion in the 1890s. Charles Dana Gibson was a member of the wedding party of the famous war correspondent Richard Harding Davis and Cecil Clark at St. Gabriel's Church in May 1899. Ethel Barrymore was also in the wedding party as the maid of honor.

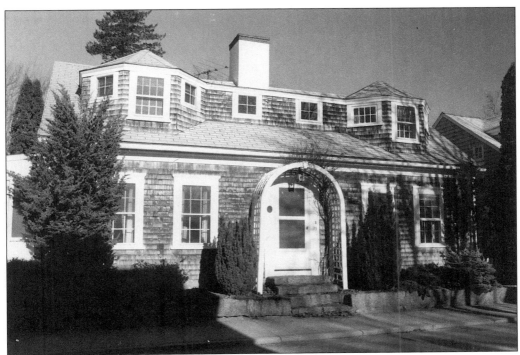

15 Main Street. The 1855 and 1879 Marion maps do not clearly identify the owners of this early 19th century cottage at 15 Main Street. The story goes that during renovations, which included new plumbing in later years, a blocked passageway made of bricks that led under the street was discovered under the kitchen. Some believe that it may have been part of the Underground Railroad. During the early 20th century, Paul A. Briggs, a teamster, lived here.

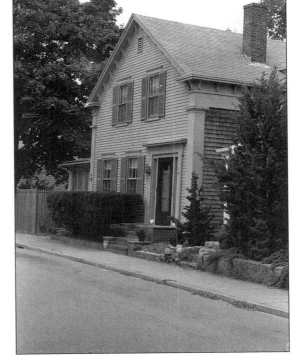

17 Main Street. The mid-19th century Greek Revival and Italianate house at 17 Main Street is an example of a one-and-one-half-story gable house. This cottage was built for Henry C. Nye between 1855 and 1879. By the early 1900s, this house was owned by James F. Hammond, a mechanic.

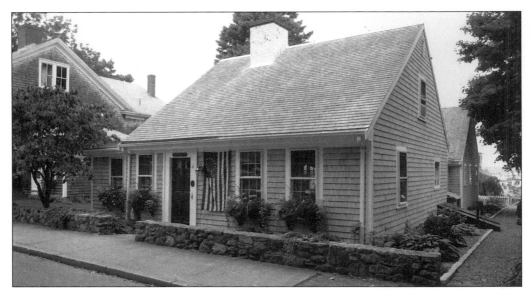

21 MAIN STREET. The oldest dwelling in Marion, dating to the 1690s, stands at 21 Main Street. This modest wooden shingle half cape was built for a member of the Ryder family. This historic home is important not only because it is Marion's oldest surviving home, but also because it typifies the town center's most widely represented and historic residential style: the Cape Cod cottage. These compact houses were ideally suited for the harsh New England climate and could easily be enlarged to meet the changing needs of families. In fact, few Massachusetts town centers possess the charm and historic character of Marion's Wharf Village.

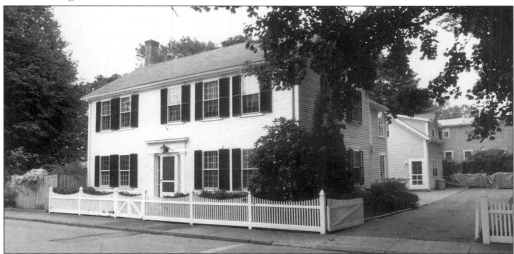

22 MAIN STREET. The house at 22 Main Street dates to the 1820s. Built for Capt. William C. Hathaway, "the last captain of Marion's last whaler," this substantial house attests to the comfortable living available to those who achieved the rank of sea captain. Captain Hathaway's ship, the *Admiral Blake*, made its last voyage in the 1880s. The vessel's last cargo of oil was unloaded at Long Wharf and hauled to New Bedford by oxen. By the early 1900s, Captain Hathaway's son, William, and daughter-in-law, Annie, lived here. Variously listed as a laborer and painter, William lived here with his wife until at least the mid-1920s.

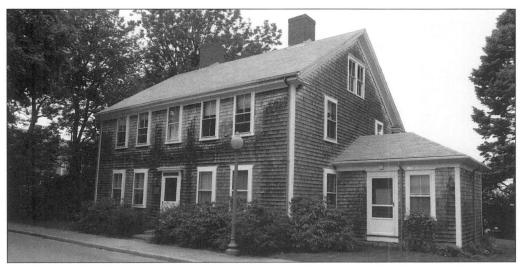

25 MAIN STREET. Built in the 1800s, 25 Main Street is a two-story late Georgian dwelling built for Maj. Rowland Luce, a prominent deacon in the Congregational Church. Luce was one of the ten prominent Marion men who each pledged $1,000 toward the construction of the Marion Congregational church. By 1855, the owners of the property were M. and B. Luce and John M. Allen, an architect. A.E. Luce, Robert B. Hiller, and Isaac Hiller owned this house in the early 1900s. The building is divided into apartments and is known as the Hiller Apartment House today.

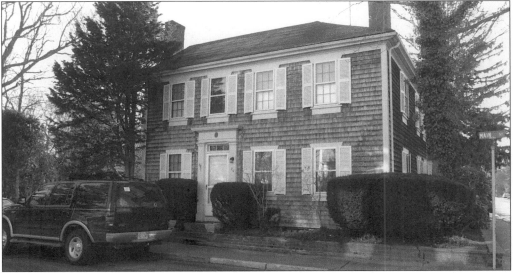

26 MAIN STREET. Few pure examples of the Federal style exist in Wharf Village. The c. 1820 Henry Kelley House at 26 Main Street is one of Marion's best examples of that style. Henry Kelley, together with his brother Lucius Kelley, the owner of 6 Main Street, were ship caulkers. During the late 19th century, Lucius Kelley inherited this house and named it Jennie Bell's, after his daughter, Jennie, who married Charles Bell Blankinship. She followed the custom of adding her husband's middle name to hers, so that she became Jennie Bell Blankinship. Lucius Kelley lived here in retirement until his death in 1917. By 1926, this dwelling had become Lena Kelley's boarding house.

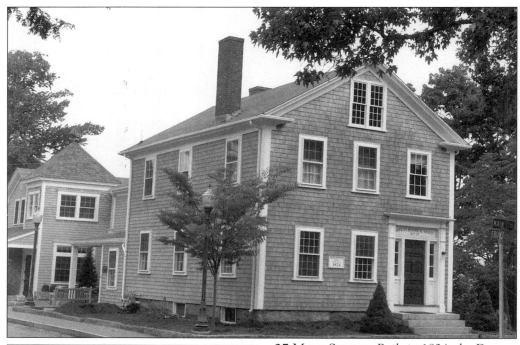

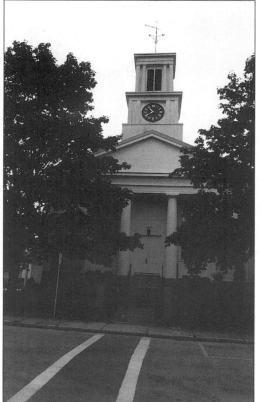

27 Main Street. Built in 1834, the Dr. Walton Nathan Ellis residence at 27 Main Street is now the Sippican Historical Society's museum. In addition to his duties as the village doctor, Ellis was responsible for founding Marion's first public library in 1855. In 1872, he helped organize the Natural History Museum above the Elizabeth Taber Library. He served as the Republican postmaster of Marion at a time when the position was a political appointment designated by the president of the United States. The small foyer of his home served as a post office (now the gift shop of the Sippican Historical Society). Ellis's daughter, Annie, married Sylvanus W. Hall, who was appointed postmaster by Abraham Lincoln and served for 36 years.

28 Main Street. The Congregational church at 28 Main Street, built in 1841, is an unusually fine example of a Greek Revival house of worship. Its main entrance opens onto a recessed porch, fronted by monumental Tuscan columns. Architect Seth Eaton of Mattapoisett designed the church and Silas Allen built it.

Side View of Marion Congregational Church. This prominent rectangular building is situated in the heart of picturesque Wharf Village. In the first decade of the 20th century, three stained glass windows designed by Charles Connick were added to the rear wall of the church. When this church was built, it symbolized the maturation of both Marion and the town center.

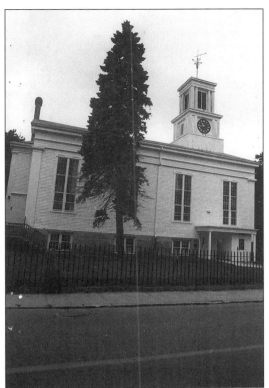

31 Main Street. This small, charming Cape Cod cottage at 31 Main Street was built in 1821 by and for Andrew Allen. As late as 1867, Allen is listed in the Rochester directory as a carpenter, owning this home until 1880. This historical home was also the childhood home of Eliza Allen Briggs, wife of Capt. Oliver Briggs. The Briggs's plans to build a residence on Pleasant Street were never realized, since Captain Briggs was lost at sea in 1872. The land on Pleasant Street was next to Rose Cottage, the house of his brother, Capt. Benjamin Briggs, who was lost at sea on the *Mary Celeste*. This house was owned by the Oliver E. Briggs estate in the 20th century.

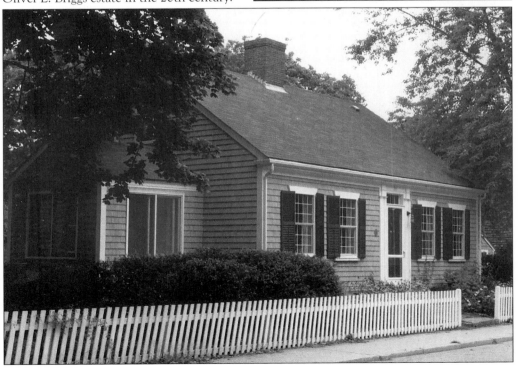

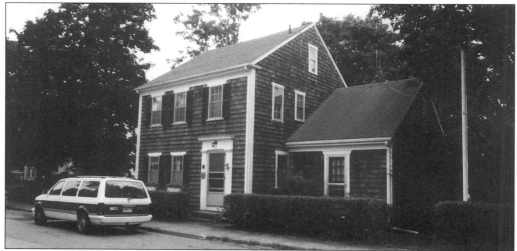

32 MAIN STREET. The home at 32 Main Street is an example of a half-house, which is characterized by a two-story main block with the main entrance located at an end bay. Built around 1830, this half-house was built for mariner Charles A. Hammond. By the early 1900s, the occupation of the Charles A. Hammond listed here was that of stone mason.

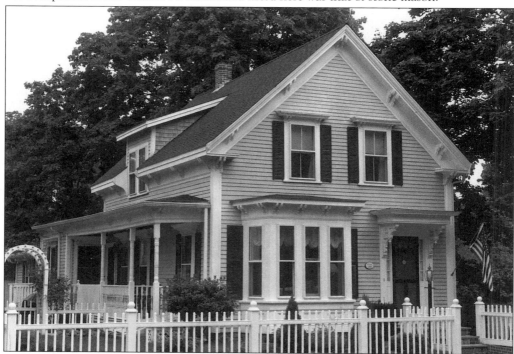

35 MAIN STREET. The home at 35 Main Street represents a late example of the Italianate style. Built in 1880, this delightful home represents a rare glimpse of late Victorian Marion on Main Street, which is predominately early 19th century in feeling. Early maps indicate that before the construction of this house, the land had been part of the Andrew M. Allen lot next door. The identity of the original owner is unclear. By the early 1900s, Charles D. Marble lived here. His occupation is variously listed as "fish" and "boating."

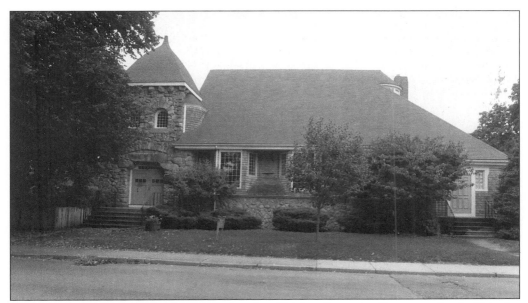

37 MAIN STREET. The Congregational chapel at 37 Main Street is a fine example of a Shingle-style ecclesiastic building. It was designed by William Gibbons Preston, a noted Boston architect, who summered in Marion and designed many buildings here. The chapel was built in 1885 by funds donated by Elizabeth Taber, Marion's benefactress.

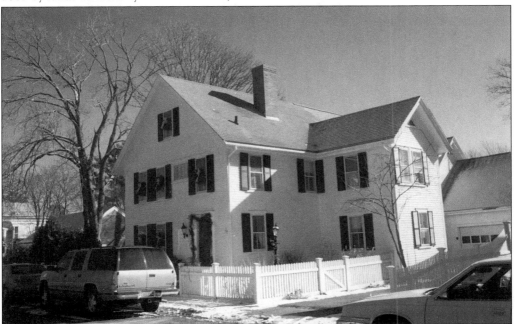

40 MAIN STREET. The center part of this Greek Revival home at 40 Main Street was moved to this location from a site on Route 6. At this location, more rooms were added to the home. In 1829, Main Street ended at this property with the road crossing through the yard of this home, continuing through South Street to Briggs' Lane, and then on to a road that led to Mattapoisett.

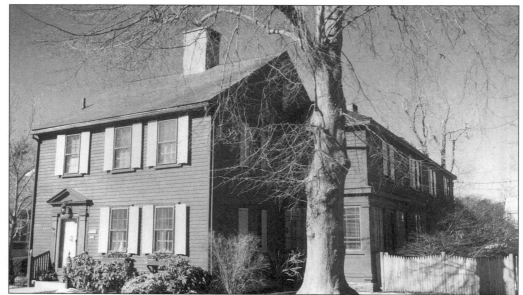

41 MAIN STREET. More usually associated with late-17th-century New England houses, 41 Main Street is a late example of a Saltbox-style home, which is characterized by a lean-to addition in the rear. Built in 1802, this was the last house on Main Street until it was extended to Mill Street in 1829. This house was built for Capt. Stephen Allen, who moved from 639 Front Street. By 1855, carpenter Silas B. Allen lived here. He was one of ten prominent Marion men, mostly sea captains, who donated $1,000 each towards the construction of Marion's Congregational church in 1841. Allen owned this house as late as 1907. In that year, he is listed in Marion directories as "92 years old, boards Mrs. B.M. Hart's, Pleasant Street."

42 MAIN STREET. The dwelling at 42 Main Street is a half cape built between 1830 and 1850. By 1855, it was the residence of Mrs. N. Briggs. From the 1870s until 1920, this was the residence of Josephine Briggs, the widow of Timothy H. Briggs, a whaling captain. He made many long voyages until he was lost at sea.

43 MAIN STREET. The residence at 43 Main Street, on the corner of School Street, was built in 1830 and was originally a primary schoolhouse for village children and the third public school in the town center. In 1855, a group of townspeople (including 21 captains) met in this schoolhouse to form the Library Association for Sippican Village. Each subscriber contributed $5.00 per year, and Mrs. Elizabeth Taber sent a donation of $200.

44 MAIN STREET. Overlooking a narrow, picket-fenced yard, the cape at 44 Main Street was built *c.* 1830. It was owned by George A. Luce, a ship's pilot, in 1855. By 1879, this property was owned by D.W. Luce. During the early 1900s, this house was owned by Augustus H. Smith, a clerk.

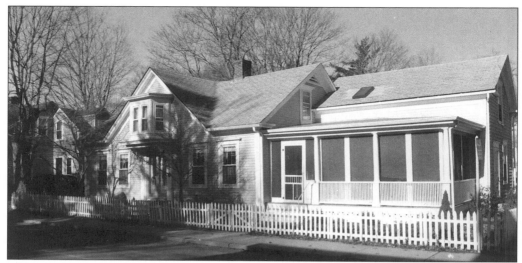

45 MAIN STREET. Built between 1830 and 1850, 45 Main Street was owned by R.B. Hammond until 1855. By the early 1900s, Dr. Albert C. Vose lived here with his wife, Ada, who operated the Village Shop in this house. Vose died on March 25, 1926.

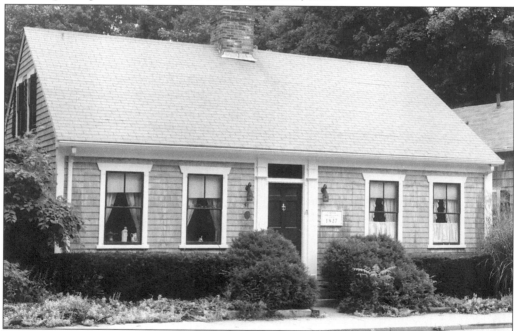

51 MAIN STREET. The cape at 51 Main Street was built in 1828 for Kezziah Hiller Look of Nantucket and her husband, Capt. Hiram Look. By 1879, this home was owned by Frank B. Coggshall. According to his May 11, 1911 obituary in the *Wareham Courier*, Coggeshall was "a Marion businessman and native of Tiverton, Rhode Island, where he was born a little over seventy years ago. A widely known businessman, having conducted a store for over twenty years, he was prominent in the Universalist Church, the Evergreen Cemetery Association Corporation and was a member of the Pythagorean Lodge for many years." This cottage was inherited by his widow and two children, Mrs. A.B. Vose and Frank V. Coggeshall.

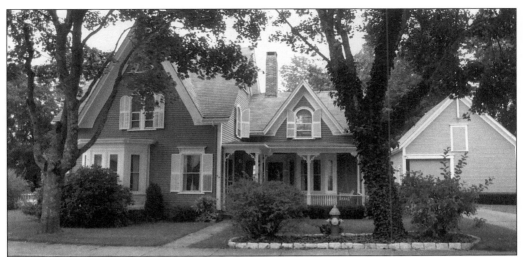

54 MAIN STREET. Built between 1850 and 1855, the Gothic Revival-style house at 54 Main Street is one of only a few examples of this style in Wharf Village. In 1855, the house was owned by John B. Nye, proprietor of the Marion Strawberry Gardens, and John B. Blankinship, a farmer. By 1879, B. Church lived here. In the early 1900s, market gardener Henry C. Nye owned this property. By 1916, Nye was the treasurer and tax collector for the Town of Marion. He married Sarah Cole Nye in 1866. Born in Rochester in 1844, Mrs. Nye was the daughter of John Cole and Mercy Le Baron, a direct descendant of Dr. Francis Le Baron, who settled in Plymouth Colony seven generations earlier, where he practiced medicine. Mrs. Nye died in 1938 at age 95. Her daughter, Helen C. Nye, a bookkeeper, inherited this lovely property.

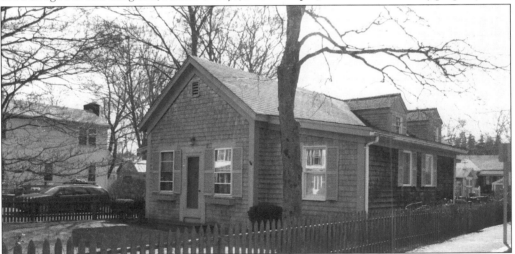

58 MAIN STREET. The home at 58 Main Street was originally located behind the Congregational church and was moved to its present location between 1855 and 1879. The center component of this 1830s cottage is said to have been a post office. At that time, the job of postmaster was a political appointment and Capt. Nathan Briggs, a Democrat, operated this post office. He was the father of Benjamin Briggs, the captain of the *Mary Celeste*, which mysteriously disappeared at sea. Because of the opposition of having two rival post offices in this small village, Captain Briggs was persuaded to give up his post office. By 1879, this structure was the home of Mrs. J. Ryder. By 1903, it was owned by S. Perrine.

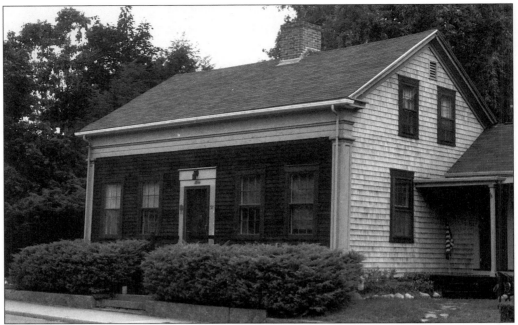

59 MAIN STREET. The Greek Revival-style home at 59 Main Street was built in 1844 for and probably by carpenter Noah Handy. By 1900, this house had been inherited by his daughter, Cynthia M. Handy, who operated a lodging house there, the Handy Inn, in the first decade of the 20th century. Miss Handy's Inn was short-lived, as it is not mentioned in the 1920s directories. She lived here until at least 1926.

66 MAIN STREET. The dwelling at 66 Main Street was built *c.* 1840 for and probably by Warren Blankinship, a carpenter. By the early 1900s, Blankinship's estate owned this property.

76 Main Street. Like so many properties in Marion's town center, 76 Main Street illustrates the great degree to which granite is integral to the historic character of an old house. The home is situated on top of a two-foot-high retaining wall composed of granite blocks, and the front steps are made of granite. Built in 1840, this Greek Revival cottage was owned by B. Chamberlain in 1855. Between the 1870s and early 1900s, this house was owned by William Handy, a master mariner.

99 Main Street. The home at 99 Main Street was built c. 1860. It appears on the 1879 Marion map, labeled "Charles A. Clark." A carpenter by trade, Clark was probably responsible for the construction of this house. He owned this property until at least the early 1900s.

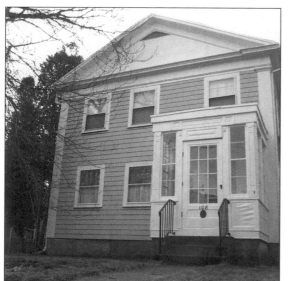

108 MAIN STREET. The Greek Revival home at 108 Main Street was built in 1841 for Elijah Brayley. A carpenter by trade, Brayley was probably responsible for the construction of this structure. After the Civil War, Brayley operated his house as a so-called "tramp house" for Civil War veterans who were experiencing difficulties readjusting to civilian life. In return for providing these men with food and shelter, Brayley received a stipend from the Town of Marion. In 1873–1874, he served as Marion's "herring inspector."

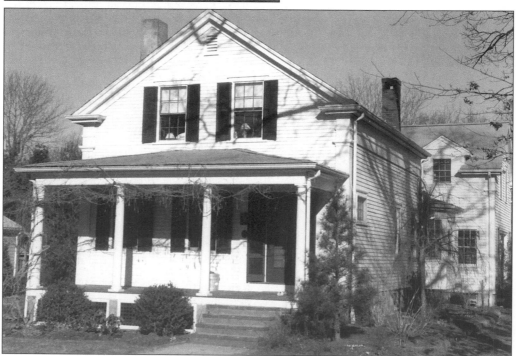

61 PLEASANT STREET. The home at 61 Pleasant Street was built c. 1850. Its earliest identified owner was Austen Lovell, an expressman. By the late 1870s, R.F. Hart owned this residence. His wife, Bertha M. Hart, lived here until her death in the late 1930s. Mrs. Hart's first husband was Gamaliel Morss of Marblehead, who was a member of the 8th regiment. He was part of the unit that escorted the Prince of Wales during his 1859 visit to Massachusetts. Morss was one of the first men killed in the Civil War. The Harts remembered being in a boat moored alongside that of Abraham Lincoln on the Potomac River at City Point in Washington, D.C. The first eight years of the Harts's marriage was spent at sea. They lived in this home for over 60 years.

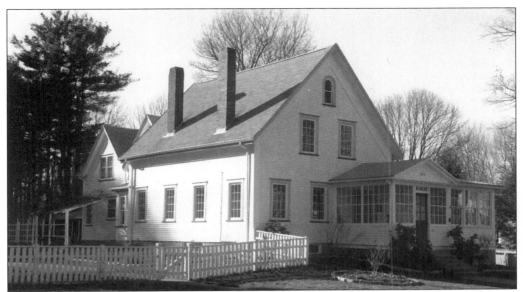

62 PLEASANT STREET. Carpenter Augustus Handy bought the land at 62 Pleasant Street in 1853 and, with Noah Handy, built this house the following year. In 1879, this property was owned by the estate of Augustus Handy. In the early 1900s, Handy's daughter, Priscilla Handy Hadley, lived here with her husband, Peleg Hadley. Priscilla and Peleg Handy were married in 1877. Peleg Hadley was the son of Andrew Hadley, the proprietor of Marion's general store. Peleg Hadley initially worked in his father's store, later establishing a poultry business. He served as town auditor and selectman. He died in this house on July 17, 1931 at age 82.

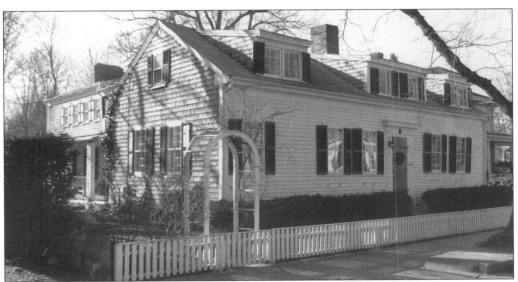

72 PLEASANT STREET. The home at 72 Pleasant Street evolved from a one-room schoolhouse built in 1814. It was one of the first non-graded schools in Wharf Village and was reportedly very crowded. Children as young as four years old would sit next to grown-up boys on benches that held three people. The school year ran from December 1 to March 1 so the children could work the rest of the year to help their families.

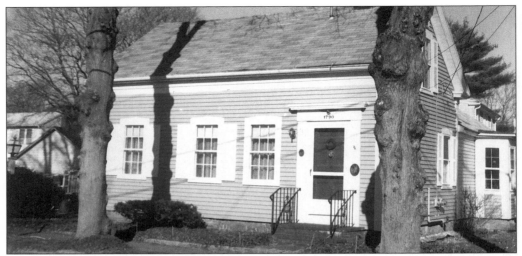

73 PLEASANT STREET. The home at 73 Pleasant Street was built in 1790 for a member of the Handy family. From the late 18th century to the early 1900s, Pleasant Street north of Pitcher Street was essentially a Handy neighborhood with a number of dwellings in this area associated with this family. In the mid-19th century, carpenter Pardon Handy owned this cottage. By the late 1870s, James W. Blankinship, a mariner, lived here. He enlisted in the Union Army during the Civil War. By the early 1900s, this house had been inherited by Blankinship's widow, Sussannah. Later, Lucy A. Blankinship, a clerk, lived here.

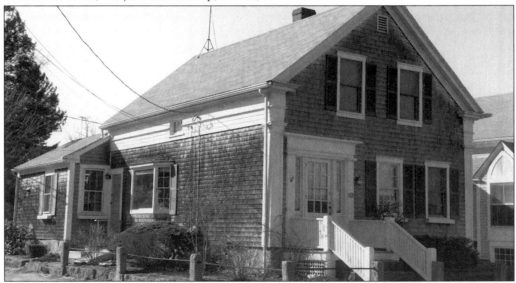

78 PLEASANT STREET. The former Universalist Church Parsonage at 78 Pleasant Street is one of the town center's earliest examples of a Greek Revival cottage. Built in 1833, it may have been designed by Seth Eaton of Mattapoisett, the architect of the Marion Universalist church. The first Universalist minister to reside here was Theodore K. Taylor. From 1866 to the late 1880s, Rev. Henry C. Vose lived here. He had also served as minister of this church from 1841 to 1844 and from 1854 to 1857. By 1903, Rev. H.E. Roulliard lived here. Evidently, this dwelling ceased to serve as a parsonage around 1950, when the low enrollment of parishioners caused the Universalist Society to disband.

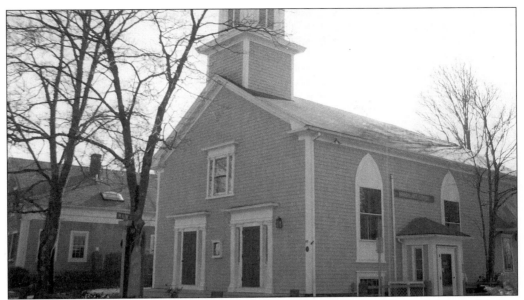

80 PLEASANT STREET. The former Universalist church at 80 Pleasant Street (now the Marion Art Center) is a blend of the Greek Revival and Gothic Revival styles. It was built in 1833 from designs provided by Seth Eaton in Mattapoisett. This building is historically significant as the spiritual home of Marion Universalists for over 100 years. The first Universalist preacher in Marion was Robert T. Killam. Alanson St. Clair was the minister during the church's construction in 1833. The original congregants included members of the Clark, Bassett, Bates, Blankinship, Foster, Martin, Southworth, and Wing families.

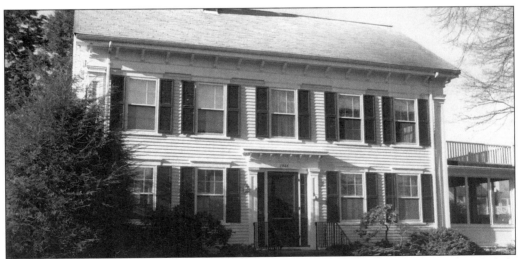

7 SOUTH STREET. The homes on South Street have more ample lots and were built slightly later than those on Main Street. The clapboard house at 7 South Street was built in 1866 by Lemuel Kelley. Its style is a blend of Greek Revival and Italianate. The story is told that Lemuel Kelley hoped to marry Jane Luce, but she married a member of the Cobb family and lived across the street. Lemuel Kelley, therefore, never lived in this house. By 1879, W. Pomeroy owned this house. It was owned in the early 1900s by Miss C.A. Pomeroy.

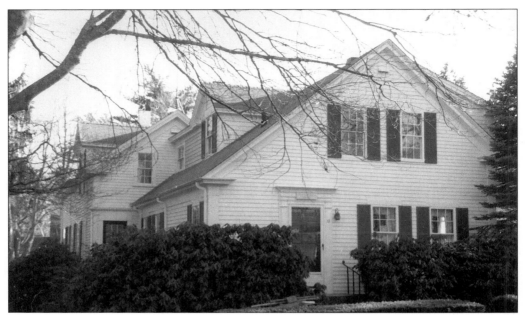

12 SOUTH STREET. The home at 12 South Street was built in 1845 by Capt. Russell Grey and is an example of a one-and-one-half-story Greek Revival gable house. In the late 19th century, it was the residence of Capt. William H. Cobb, the captain of a coastal schooner. He was active in community affairs and, in 1919, was selectman, assessor, and "overseer of the poor." Captain Cobb lived here until his death in 1920. His widow, Henrietta Cobb, was listed in the town directory as living here in 1926.

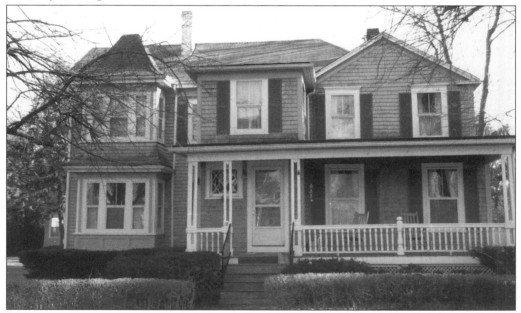

18 SOUTH STREET. The house at 18 South Street evolved from a small "shop" as indicated on the 1855 Marion map. It achieved its present complex form between the mid-1850s and 1880s. For many years, it was the home of master mariner Capt. Henry C. Lewis.

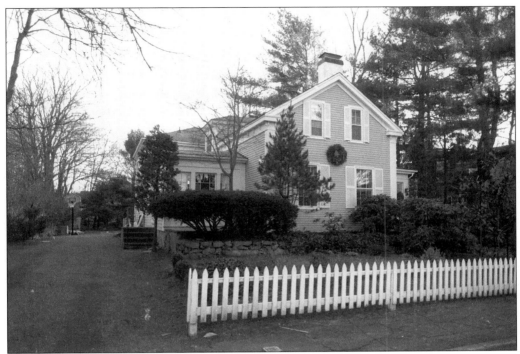

20 SOUTH STREET. Reportedly built in the early 1800s, the first owner of 20 South Street may have been J.G. Luce. By 1879, this house was owned by Charity and Samuel W. Waters. The Waters emigrated from England to Massachusetts around 1820 and initially lived in the 1823 cottage at 80 Water Street, a dwelling that originally stood next to St. Rita's Rectory at 113 Front Street. By the early 1900s, this property had passed to their son, the prominent local businessman Benjamin E. Waters. He was the manager of the local telephone company and had considerable real estate holdings in Marion, including the upscale enclave of residences at Pie Alley. The Benjamin Waters family lived here until as late as 1963.

24 SOUTH STREET. Built between 1830 and 1850, the Greek Revival house at 24 South Street was owned by Stephen C. Luce in 1855. George L. Luce owned this house from the 1870s until at least the first decade of the 20th century. He was the proprietor of the Marion general store during the early 1900s. His business is listed as "groceries and dry goods, Main, corner Front." By 1916, Ida and George I. Luce, a master mariner, lived here. In 1919, George I. Luce was the second assistant to Marion's fire chief. In that year, he served as an agent for Marion's School committee. In addition to George I. Luce, James D. Luce, a clerk, and Louise B. Luce, the widow of John F. Luce, are listed in the town directory as living here in 1926.

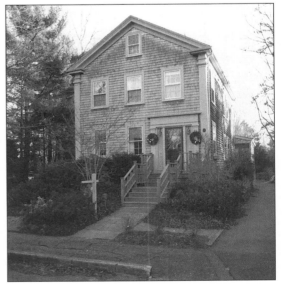

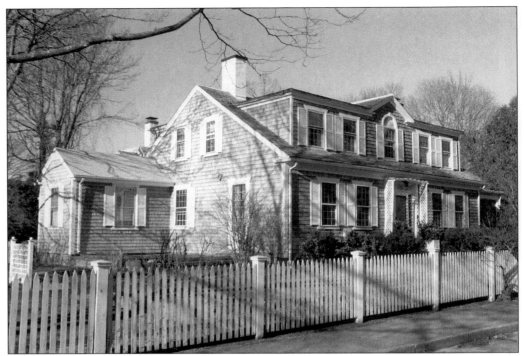

25 SOUTH STREET. The full-length Colonial Revival dormer added to the house at 25 South Street transformed the Capt. Samuel Luce House into a dignified two-story residence. The nucleus of this house is said to date to 1799. Its original owner, Capt. Samuel Luce, was another one of the ten Marion men who contributed $1,000 to the construction of Marion's Congregational church. The side yard to this home contains a lovely garden.

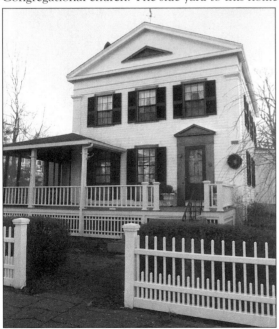

28 SOUTH STREET. Representing one of the most stylish and substantial examples of the Greek Revival style in Marion, the two-story former parsonage at 28 South Street was built in 1841 for Congregational minister Rev. Leander Cobb. The lot is enclosed by an exceptionally handsome mid-19th-century picket fence. The first pastor to reside here, Rev. Leander Cobb, assisted his father, Rev. Oliver Cobb, who had been preaching in Marion since the completion of the first meetinghouse (now the Marion general store) in 1799. After his father's death in 1849, Rev. Leander Cobb was the Congregational minister in Marion until his death in 1872. His daughter, Sarah Elizabeth, married Capt. Benjamin Briggs in 1862, who, along with their baby, were lost at sea on the *Mary Celeste.*

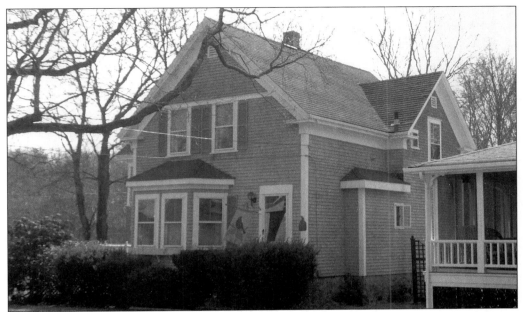

54 SOUTH STREET. The western segment of South Street between Front and Pleasant Streets was built up much later than the majority of the town center's streets. The modest Italianate and Queen Anne residence at 54 South Street is typical in terms of scale of the housing that was built on South Street, where the former Academy Field for Sippican Academy (now St. Gabriel's Chapel) was located. Built around 1890, this house was owned by B. Ball, a carpenter, during the 1890s.

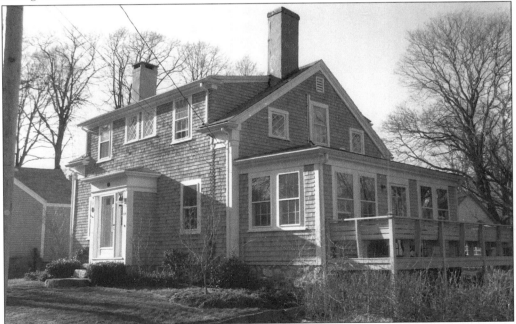

59 SOUTH STREET. The *c.* 1790 frame cottage at 59 South Street was built for members of the Handy family.

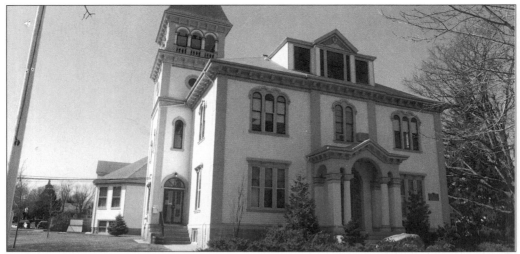

2 SPRING STREET. Spring Street started out as a country lane leading to a stone building associated with Captain Allen's salt works. The Marion Town House at 2 Spring Street is an Italianate building erected in 1875–1876 as Tabor Academy's recitation or classroom building. The school owes its existence to Elizabeth Taber, who purchased the rock-strewn land from Capt. Henry M. Allen in 1871. Tabor Academy opened on September 13, 1877 with 21 students.

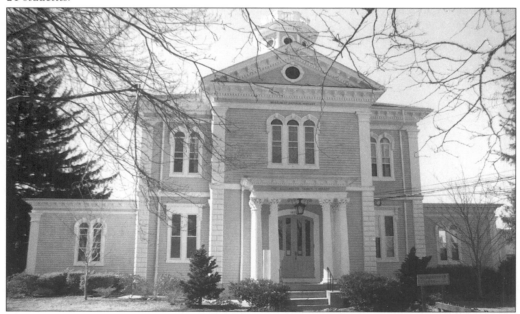

8 SPRING STREET. The Italianate building at 8 Spring Street houses the Elizabeth Taber Library on the first floor and the Natural History Museum on the second. Built in 1872, this building was the first of numerous gifts of buildings to the Town of Marion by Elizabeth Taber. She stated that her gift represented "a testimonial of my esteem and kind regards for the Library Association and Natural History Society and for the inhabitants of Marion, generally." She had the building insured for $4,000. By the late 1870s, the Taber Library and Natural History Museum had become a key component of the Tabor Academy campus.

11 Spring Street. The Pythagorean Lodge at 11 Spring Street was built between 1909 and 1911. It blends elements of both the Classical and Colonial Revival styles. For many years, Pythagorean Hall had been housed in a building near Burr's Boat Yard in the Old Landing area. Pythagorean Hall was the first major institutional building in Marion to have been electrified from the very beginning. Electricity was introduced to the Marion in 1910. Since its founding on August 10, 1861, Pythagorean Lodge (which housed the Masons) has been an important social and charitable organization in the town. Col. Henry E. Converse was its major benefactor, funding one-third of its $20,000 cost.

16 Spring Street. The yellow brick Sippican School at 16 Spring Street was built in 1930. This grammar school blends Colonial Revival and Art Deco styles in a mostly horizontal building. It was built on land formerly owned by Tabor Academy following a "Tabor swap" of land with the town.

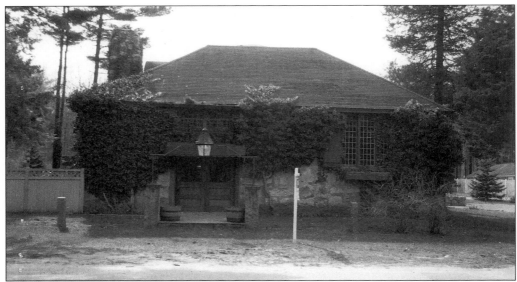

46 SPRING STREET. The Old Stone Studio at 46 Spring Street was built in 1820 and is significant as a rare surviving storage facility associated with the early 19th-century salt industry in Marion. By 1860, it housed Captain Allen's petroleum oil refinery. However, it is most known as the "Old Stone Studio," when it was purchased by Richard Watson Gilder, the editor of *Century Magazine*, as a studio for his artist wife Helena deKay Gilder. In the 1880s and 1890s, the Gilders hosted a salon within this building, which attracted well-known writers, artists, actors, architects, musicians, politicians, sculptors, and philanthropists. The roster of persons in attendance at the Gilders' theatrical performances, poetry readings, and musical performances included many celebrities, including Stanford White, who designed the Old Stone Studio's chimney addition in 1883.

Three

CONVERSE POINT AND GEORGE BONUM NYE HISTORIC AREA

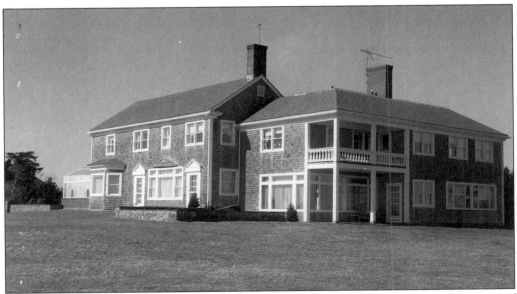

THE MOORINGS. The Moorings is situated at the tip of Converse Point, the southernmost of the two necks that shelter Marion's Sippican Harbor. Converse Point was formerly called Charles Neck and was a Native American campground for centuries before the English settlement of Marion in 1679. This Colonial Revival-style home was built in the mid-1920s to replace the much larger late-19th-century Shingle-style Moorings estate that had 40 rooms.

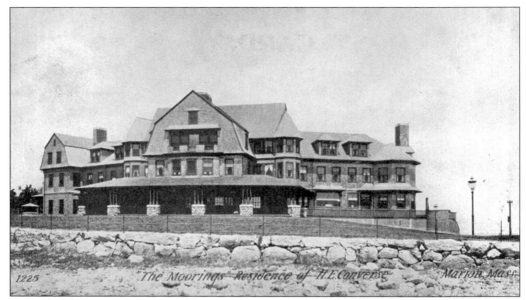

ORIGINAL MOORINGS. The first Moorings was built in 1890 for Harry E. Converse, who was an heir of Elisha Converse. The founder of a rubber products industry in Malden during the 1850s, Elisha Converse's rubber shoes were in great demand world-wide. Harry E. Converse was an important local philanthropist who funded many causes, including Marion's fire department.

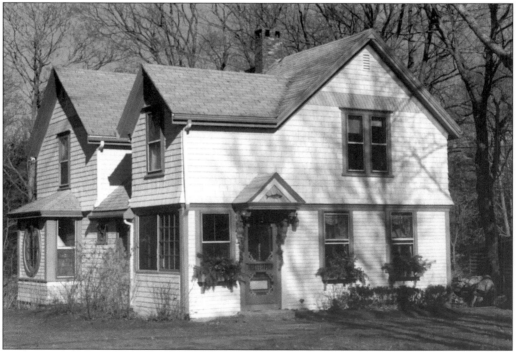

9 CLARK STREET. The dwelling at 9 Clark Street is a U-shaped Queen Anne house built between 1855 and 1875. By 1879, it was owned by Joseph H. Clark, a carpenter and boat builder. He lived here from the 1870s until *c.* 1910.

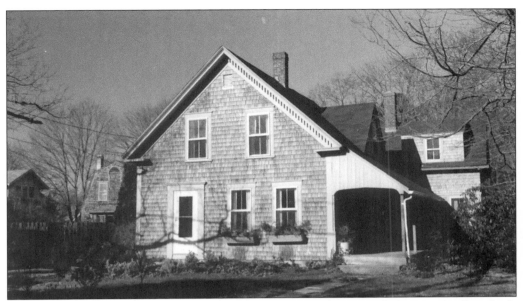

11 Clark Street. The home at 11 Clark Street is a charming, Italianate dwelling built between 1855 and 1875. As early as 1867, it was owned, but not occupied by Ernest S. Clark, a carpenter. This property is listed on the 1879 map as belonging to S. Blankinship.

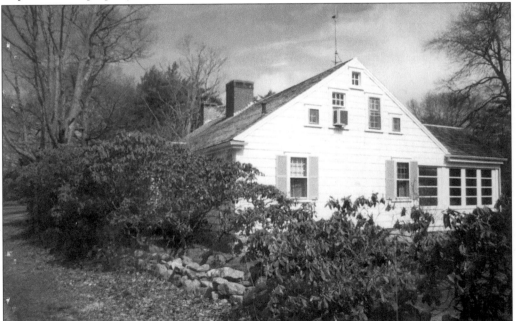

135 Converse Road. The Cape Cod cottage at 135 Converse Road reportedly dates to the mid-to-late 18th century. This home provides evidence that before the development of Wharf Village as the town's center in the early 1800s, housing in Marion was widely dispersed among the most remote areas of its road system. Converse Road, variously known as Nye and Pleasant Streets, once extended only as far as this house. Weston Allen, a farmer, owned this house in 1855. By the early 1900s, this house had passed from the Allens to E. H. Wisner.

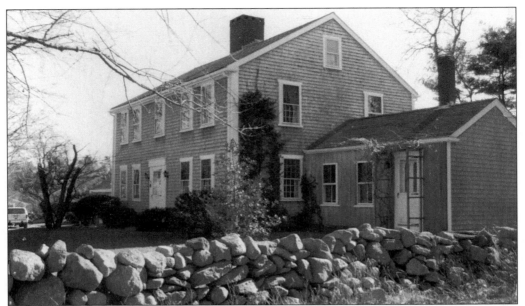

266 CONVERSE ROAD. The late Georgian-style house at 266 Converse Road was built *c.* 1800 by the prominent salt industry pioneer, George Bonum Nye, who was a member of Marion's industrious Nye family. The story of the Nye family in Massachusetts began in 1637 when Benjamin Nye immigrated from England. Marion's Nyes are descended from Ichabod Nye of Middleboro, who settled in Marion in 1720. King George I granted a 1,100-acre tract in Marion to Ichabod Nye for 35 pounds. This tract encompassed much of the southern outskirts of Wharf or Sippican Village as well as Charles Neck. In fact, Converse Road was originally called Nye Street, which probably evolved from a Native American trail.

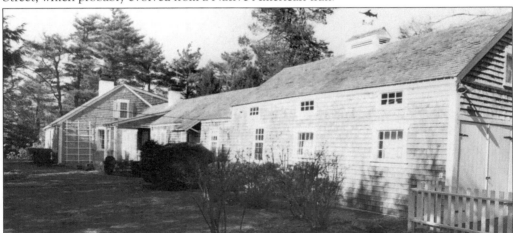

273 CONVERSE ROAD. On the corner of Allen Street and Converse Road, the rambling house at 273 Converse Road presides over the sweeping curve formed by Converse Road's intersection with Pleasant Street. Built in 1820 for a branch of the Blankinship family, this Cape Cod house stands on high ground that was called Christian Hill during the 19th century. Blankinship is said to have paid a local carpenter $75 to build the initial portion of this house. By 1855, J.B. Blankinship, a farmer, owned this house and in 1879, Allen and Hadley are listed as this house's owners. By 1903, Mrs. L.W.R. Allen is listed as owner.

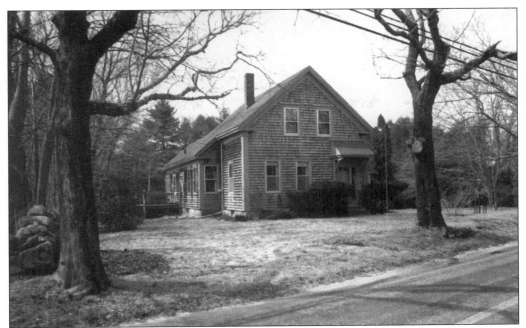

290 CONVERSE ROAD. The modest wood shingle-clad Italianate cottage at 290 Converse Road was built c. 1880 for and probably by Francis C. Blankinship, a "carpenter and builder." He lived here until at least 1910.

300 CONVERSE ROAD. The dwelling at 300 Converse Road is a Queen Anne house noteworthy for its well-preserved encircling verandah. Built in 1894 for the carpenter H.V. Blankinship, this house, with its ornate gingerbread porch, illustrates Blankinship's carpentry skills.

303 CONVERSE ROAD. The home at 303 Converse Road is noteworthy as stucco Craftsman-style bungalow from around the first decade of the 20th century.

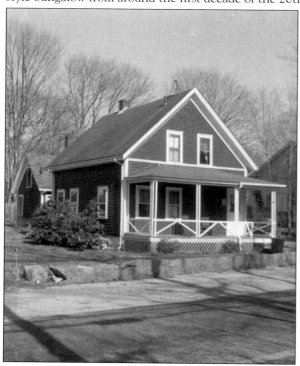

307 CONVERSE ROAD. The charming Queen Anne home at 307 Converse Road was built between 1879 and 1900 for G. A. Merithew.

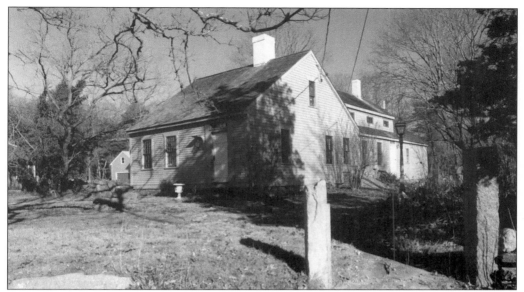

319 Converse Road. The Cape at 319 Converse Road may date to the mid-18th century. Retaining much of its original character, it is situated at an angle to Converse Road, its front yard marked by very old granite posts. In 1855, this home was owned by Z. Dexter. From the late 19th century to the first decade of the 20th century, E.G. Mendell owned this property.

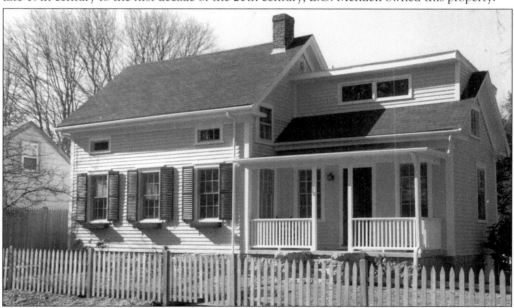

79 Lewis Street. The Italianate home at 79 Lewis Street was built *c.* mid-19th century. Particularly noteworthy are the eyebrow windows, which were rarely incorporated into the design of New England residences after 1860. This house may have been moved to Lewis Street from another location, as it does not appear on either the 1855 or 1879 Marion maps. This cottage is shown on the 1903 Marion map. At that time, it was owned by Nathan B. Nye, who also owned 83 Lewis Street and whose occupation is listed as "hand laundry." He owned these properties until 1920.

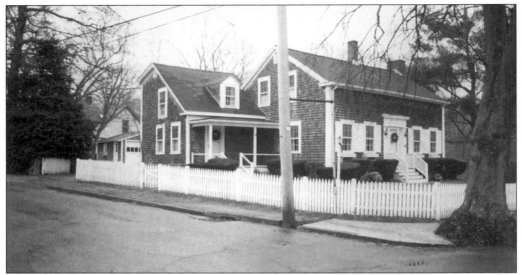

16 PLEASANT STREET. The *c.* 1840 Greek Revival residence at 16 Pleasant Street was owned by J. Randall in 1855. Its ownership is not identified on the 1879 Marion map. The 1903 map indicates that this residence was owned by H.C. Lewis.

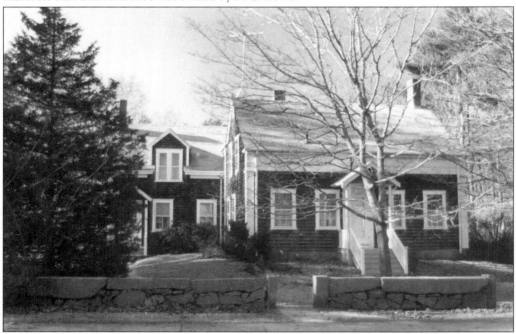

26 PLEASANT STREET. The Greek Revival residence at 26 Pleasant Street was owned by L. Berry in 1855 and, in 1879, by H. P. Babcock. In the late 19th century, this house was purchased by Ichabod N. Blankinship. Ichabod, born in 1817, grew up at 273 Converse Road, which was owned by his father, John Blankinship. Ichabod was a parishioner of the Universalist Church, a sympathizer of the anti-alcohol Temperance Movement and an ardent Democrat who voted for the Republican Abraham Lincoln in 1864. By 1903, J.B. Blankinship, an ice deliveryman, owned this home. Ichabod N. Blankinship died in 1909 at age 92.

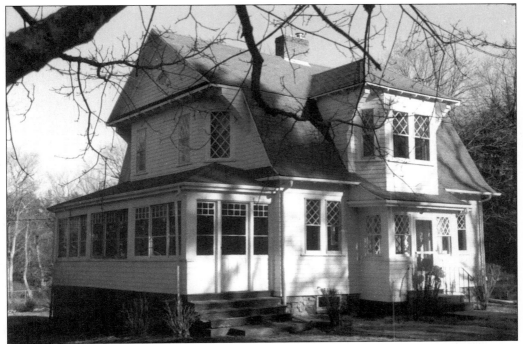

35 PLEASANT STREET. The home at 35 Pleasant Street is a compact, early 1900s Queen Anne residence that was carved from an enormous tract of land owned by salt industry entrepreneur Ebenezer Holmes. The Holmes's land extended eastward from Pleasant to Front Street and from the back lot lines of house lots bordering Pitcher Street, almost as far south as Allen Street.

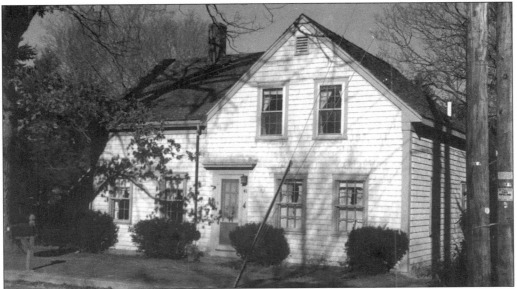

41 PLEASANT STREET. The Greek Revival dwelling at 41 Pleasant Street was built between 1855 and 1875 and was also carved from the extensive holdings of Marion salt industry entrepreneur Ebenezer Holmes. Owned by Mrs. Freeman in 1879, this house had been purchased by H.F. Weeks by 1903.

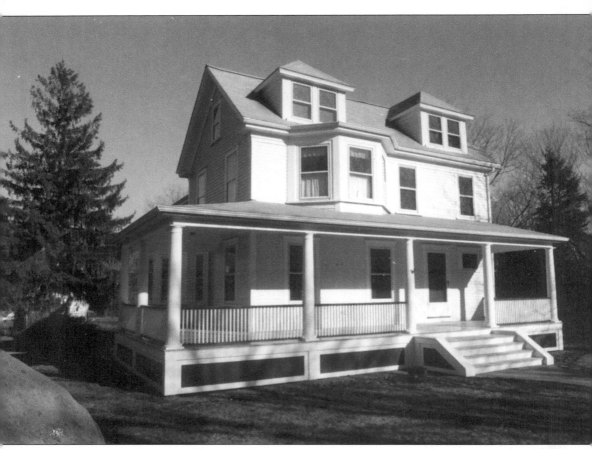

48 PLEASANT STREET. The *c.* 1905 Queen Anne residence at 48 Pleasant Street has a large rock at the northwest corner of the lot known as Split Rock. The land had been owned by the Weeks family during the early 1900s.

Four

Tabor Academy

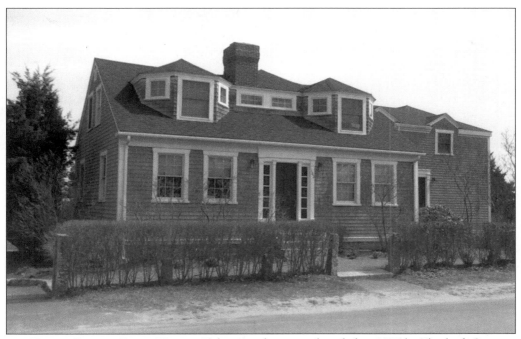

183 Front Street. Pond House. Tabor Academy was founded in 1876 by Elizabeth Sprague Pitcher Taber (1791–1888). In 1916, Walter Huston Lillard became headmaster of the school and he consolidated the campus along the shores of Sippican Harbor. In 1936–1937, the "Tabor Swap" involved the exchange of three acres of the town's waterfront land for ten acres of Tabor Academy's land on Spring Street. Tabor gradually purchased homes along the waterfront, which were used as dormitories. The Pond House at 183 Front Street was built in 1797. In the 1880s, John Hay and John Nicholay, both former secretaries to President Abraham Lincoln, lived here while rewriting their biography of Lincoln for *Century Magazine*. This building is currently a dormitory for Tabor Academy.

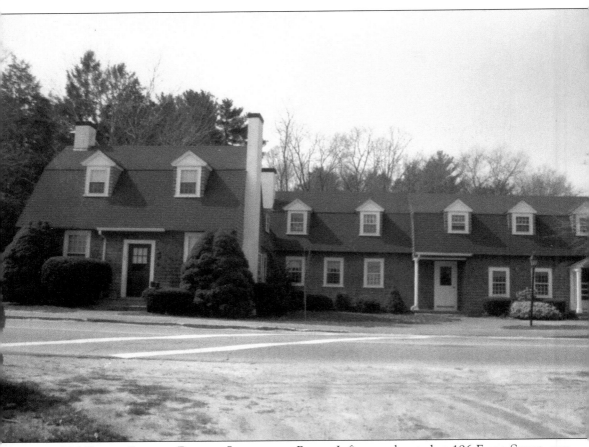

196 Front Street. Baxter Infirmary. Baxter Infirmary, located at 196 Front Street, was built in the early 19th century. In 1855, it was owned by John Burgess, who drove Sippican's glassed-in hearse and always wore a high silk hat when he headed a funeral procession. Burgess is listed as the building's owner in 1855 and 1879. By the early 1900s, C.E. Hellier owned this house. Tabor Academy acquired the house for the purpose of establishing an infirmary. Named for Dr. Raymond Harding Baxter, who had faithfully served the town since 1921, the new infirmary provided Tabor Academy students and faculty with a more up-to-date medical facility.

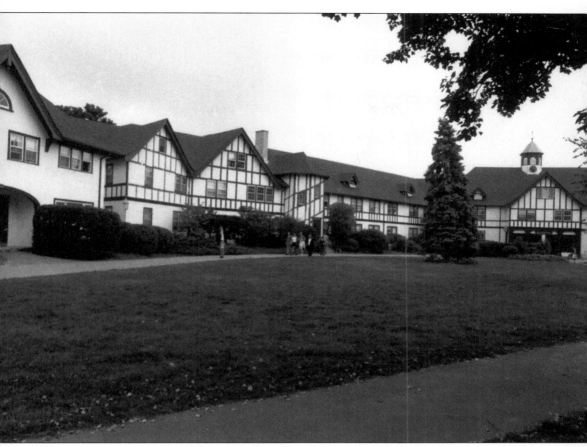

217 FRONT STREET. LILLARD HALL. In 1926, the construction of Lillard Hall and the use of a private residence later known as Bushnell Hall represented an important step in the direction of forming a waterfront campus. Lillard Hall, at 217 Front Street, was dedicated on June 12, 1926 in honor of Tabor Academy's fifth headmaster. During the fall of 1927, the clock in the belfry atop Lillard Hall was dedicated by Silas Howland in the presence of his father, Clark P. Howland, Tabor Academy's first headmaster. At that time, the clock was one of only three of its size to strike the hours with ship's bells, the other being at the Portsmouth Navy Yard and the U. S. Naval Academy at Annapolis.

BUSHNELL HALL. Presently connected to the northwestern wall of Lillard Hall, Bushnell Hall (formerly known as Red Rock) had been a private residence owned by L. Daggett. It was purchased by the school in 1923 and was moved from another location to its present site and renamed. One of the early attractions of Bushnell Hall was that it had its own eating unit right in the house, thanks to the fully equipped kitchen left behind by the Daggett family. Both Bushnell and Lillard Halls were severely damaged during the fierce hurricanes of 1938 and 1954.

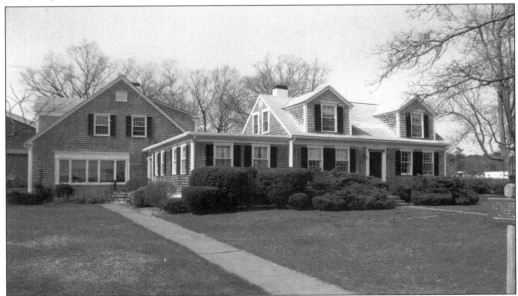

226 FRONT STREET. ALUMNI HOUSE. The building at 226 Front Street, once the Headmaster's House, is a Cape Cod cottage that was built in 1817. It was greatly enlarged by a Colonial Revival addition in 1949. The 1855 Marion map indicates that Peleg Briggs lived here. By 1903, it was the property of Miss J. Briggs. In 1937, it became the Headmaster's House when Tabor Academy was moved to the waterfront. Headmaster Walter Huston Lillard lived here until 1942, when he left Tabor Academy to assist the war effort. His successor was James W. Wickenden. The Headmaster's House became an important focus of the school's academic life.

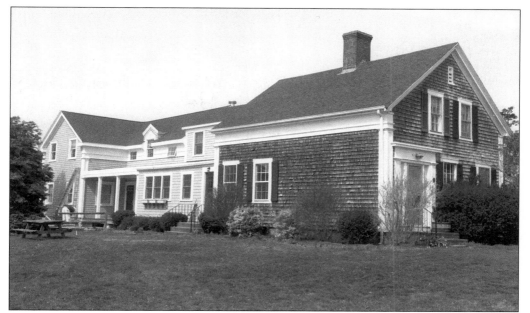

260 FRONT STREET. FOC'S'LE HOUSE. The building at 260 Front Street was built *c.* 1830 and was at one time occupied by the local stagecoach driver. It had been owned by the Allanach family when it was purchased by Tabor Academy.

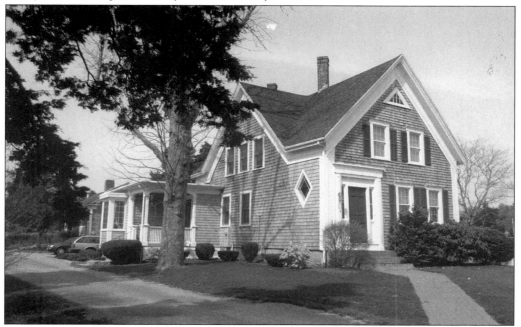

264 FRONT STREET. CHAMBERLAIN HOUSE. In 1855, the Greek Revival cottage at 264 Front Street was owned by B.A. Chamberlain. Later, Capt. Ichabod Lewis, a tea-kettle captain, bought the property. A tea-kettle captain was one who sailed up and down the coast and was not as highly regarded as those who sailed the seven seas. Another tea-kettle captain, Henry Dow Allen, was a later owner of this house.

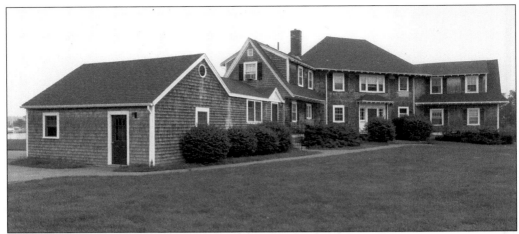

275 Front Street. Daggett House. The building at 275 Front Street represents an artful blending of the Shingle and Craftsman styles of architecture. Currently serving as Tabor Academy housing, Daggett House was built in 1913 as the permanent residence of Mrs. Hosea (Sylvia) Knowlton. The Knowltons began summering in Marion around 1890, initially renting 294 Front Street at Old Landing and moving next door to 283 Front Street in 1900. From 1920 to 1923, Tabor Academy rented this house from Mrs. Knowlton. Daggett refers to a Mr. L. Daggett who bought 275 Front Street in 1938 and sold it to Tabor Academy in 1944. Daggett had previously sold Bushnell House to Tabor Academy in 1924.

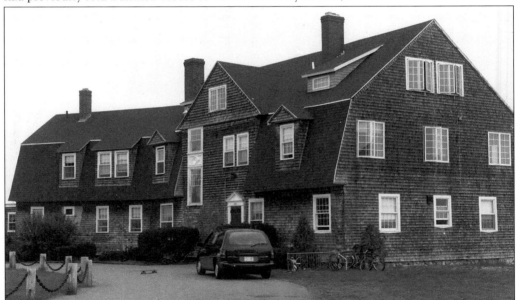

283 Front Street. Knowlton House. The structure at 283 Front Street ranks among the best Shingle-style and Queen Anne designs in Marion. Built in 1900 for Hosea Morrill Knowlton, it is now known as Knowlton House. During the 1890s, Knowlton rented the home at 294 Front Street. A resident of New Bedford and the prosecuting attorney at the Lizzie Borden murder trial in Fall River, Knowlton served as the Bristol County district attorney and the Massachusetts attorney general. Knowlton died after only two summers in this house. The Knowltons' house was purchased as housing for Tabor Academy in 1944.

Five

OLD DEPOT, ROUTE 6, AND REVEREND COBB AREA

355 FRONT STREET. In 1854, The Cape Cod Railroad established a station in Marion, connecting West Wareham with Fairhaven. By the 1880s and 1890s, the rails were bringing affluent summer visitors to Marion from all over the country. Sea captain George Allen's house at 355 Front Street—with its expansive grounds from Route 6 north to the railroad tracks—was impressive enough that the intersection of Front and Spring Streets was, for many years, known as Allen's Corners. This ornate Italianate house was built sometime before 1867, and although altered, is a fine example of a sea captain's residence.

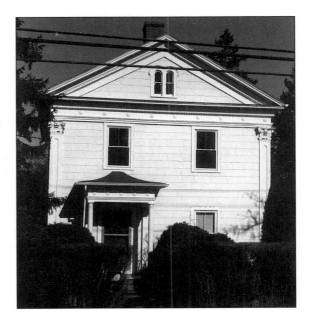

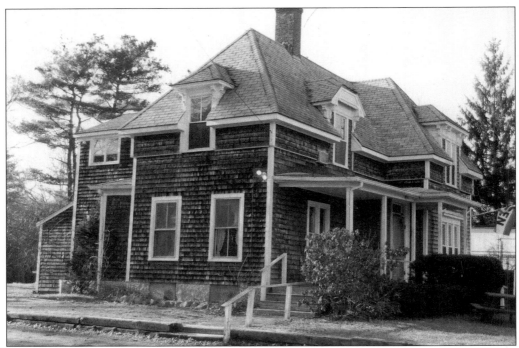

360 Front Street. The building at 360 Front Street is a rare Marion example of a Stick- and Queen Anne-style residence. It was built by the Sisson family in the late 19th century on land that had been carved out from the estate of Capt. Joseph Emerson Hadley.

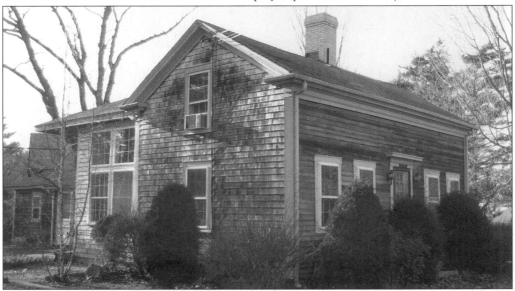

368 Front Street. The home at 368 Front Street may represent the only surviving building from the 18th- and early 19th-century cluster of residences called "Parlowtown." Parlowtown Road was originally a Native American trail that ran northwest to Rochester. It fell into disuse in the mid-19th century, when the rugged, swampy nature of the terrain made its maintenance difficult. This Federal-style cottage was built *c.* 1800 by the Parlow family.

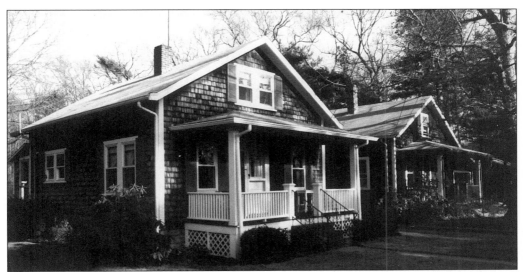

373 AND 375 FRONT STREET. After his retirement from the sea, Capt. George Allen began to expand the economic base of the Old Depot area. He demolished the neighboring one-room schoolhouse and, between 1900 and 1920, built two Craftsman-style cottages at 373 and 375 Front Street as a real estate development project. He also established a cigar and confectionery store opposite the depot. The diminutive cottages at 373 and 375 Front Street feature full-length front porches resting on lattice-covered platforms and support slat-work railings and square posts. Captain Allen augmented his retirement nest egg with the proceeds from the sale of the cottages.

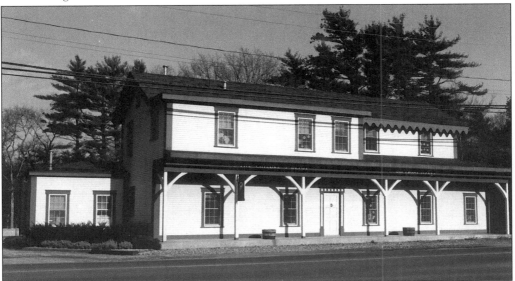

381 FRONT STREET. OLD DEPOT. In 1854, an Italianate passenger depot was built on the west side of Front Street on part of the present parking lot for the Wave restaurant. At its new location on 381 Front Street (across the street), the Old Depot became a station on the New Bedford and Onset electric trolley line. At the time, there were only two other buildings in the area: the early 1800s home at 368 Front Street and a one-room schoolhouse, which was later demolished. The schoolhouse stood north of what is now 355 Front Street.

194 Spring Street. The charming, diminutive Greek Revival-style cottage at 194 Spring Street was built between 1855 and 1870. It was the home of William R. Gifford, who became well known to tourists in Marion's Gilded Age as their gracious transportation on the last leg of their seasonal quest for beauty, peace, and recreation.

202 Spring Street. Between 1855 and 1879, Freeman F. Gurney built this Gothic Revival home at 202 Spring Street. This house is described in the Massachusetts Historic Commission archives as "the most full-blown example of a Carpenter Gothic residence in Marion." Freeman F. Gurney ran a thriving grocery store in the building across the street at the apex of Spring and Front Streets. This location allowed him to service the railroad depot.

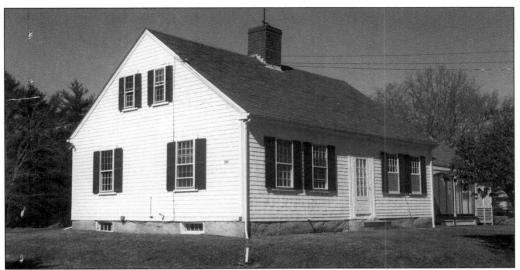

533 MILL STREET. Route 6 existed as a Native American coastal trail for centuries before the first English settlement of Marion in 1679. The Cape Cod home at 533 Mill Street was built in 1818, but is said to incorporate a room that dates to the late 17th century. The first identified owner of this home was Barnabas Holmes. He was a Quaker school teacher descended from Isaac Holmes, one of the original members of a local Congregational Church founded by Rev. Samuel Arnold in 1703. Barnabas Holmes and his wife, Sarah, left considerable property to the Town of Marion. The Holmes estate left $2,000 to the Old Landing Cemetery Association to "beautify the cemetery in which my family is buried."

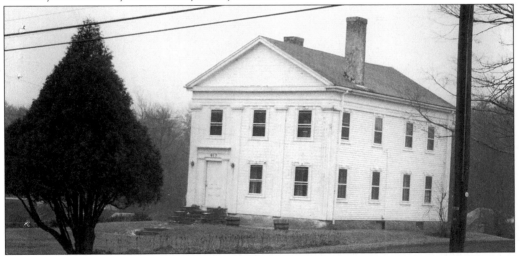

617 MILL STREET. The Greek Revival home at 617 Mill Street is set back from Mill Street (Route 6) and is noteworthy for its temple form design. Built in the 1840s, this house was for many years owned by George S. Bates and Sarah Blankinship Bates. Mr. Bates was a farmer and trader. He is listed on the 1855 and 1879 Marion maps. By 1903, this house was owned by his estate. As late as 1937, this house was occupied by two of the ten children of George and Sarah, namely, Mrs. Paul C. Blankinship and Albert S. Bates. Albert attended Tabor Academy and the Universalist Church. He was also a member of the Marion Grange and later worked in the store of his brother-in-law, Paul C. Blankinship.

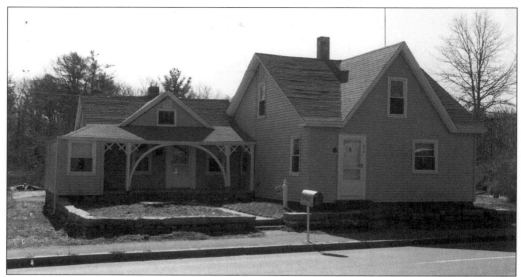

678 Mill Street. The dwelling at 678 Mill Street is situated close to the street and is located between Gifford's Corner and Converse Road. The 1855 Marion map indicates that James Wittett lived here. He was a sailmaker who served in the Union Army during the Civil War. By 1879, R. Briggs lived in this house, and the 1903 map indicates that Lucinda O. and Robert B. Barnes, a carpenter, lived here. Barnes may have been responsible for the Queen Anne porch additions to this house and to the one at 681 Mill Street. Barnes's widow lived here until at least 1916.

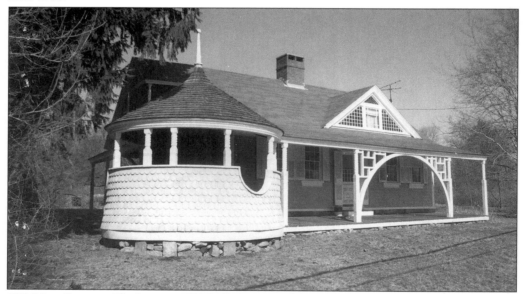

681 Mill Street. The home at 681 Mill Street is a late-18th- to early 19th-century Cape that was expanded and reworked in the Queen Anne style during the 19th century. Bethuel Dexter is listed as the house's owner in 1855. By 1879, Bartholomew W. Taber, a tailor, owned this residence. In 1903, Robert B. Barnes, a carpenter, is listed here. Evidently, part of this building was utilized as a store operated by Lucinda Barnes. Her business is listed as "groceries." No Barneses are listed here during the mid-1920s.

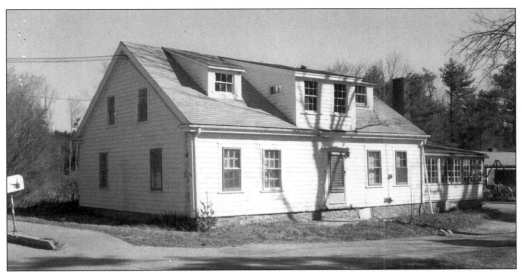

856 MILL STREET. The Cape Cod cottage at 856 Mill Street was built *c.* 1840. Both the 1855 and 1879 Marion maps show that this house was owned by Amos Hadley, a farmer. During the early 1900s, John W. Delano, the town's game commissioner, owned this house, but did not reside here. He is variously listed on Front and Cottage Streets.

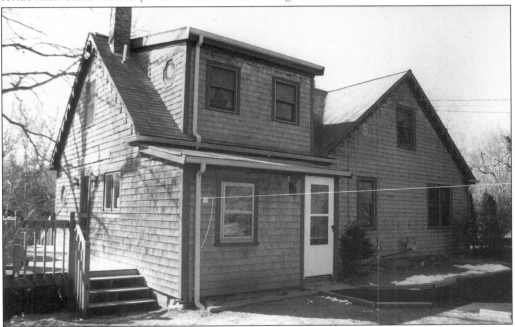

872 MILL STREET. The home at 872 Mill Street, along with its stable, exhibits elements of the Carpenter Gothic style. This *c.* 1840 home has significant local historical associations with Marion's industrious Hiller family, who had sawmill and gristmill operations in addition to an early 20th-century ice company. By 1855, Barnabas Hiller, a ship's carpenter, was the owner and probably the builder of this home. He also served on the Marion Board of Selectmen in 1863. Hiller's heirs are listed as this home's owners in 1879. The 1903 map lists the owner of this house as Albert E. Winters, a laborer, who lived here with his wife, Daisy, until 1926.

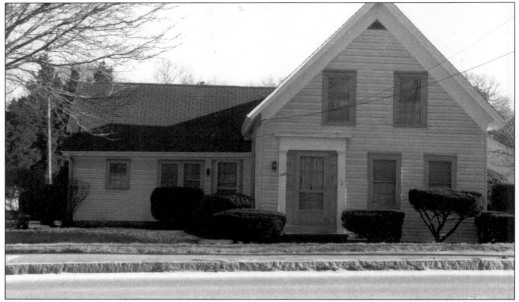

288 WAREHAM ROAD. The *c.* 1860 Greek Revival cottage at 288 Wareham Road was built for Peter A. Holmes, a butcher who resided here by 1879. By the early 1900s, Asa F. Holmes, the town's road surveyor, owned this property. He lived here until 1910.

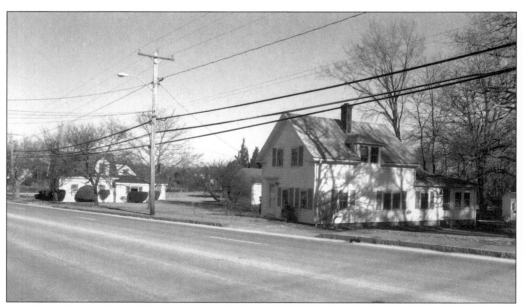

294 WAREHAM ROAD. Built between 1855 and 1879, the Greek Revival cottage at 294 Wareham Road was built as a retirement home for Captain Hale. After the whaling industry faded away due to competition from the 1859 discovery of oil in Pennsylvania, a number of these captains retired to Marion. Captain Hale was listed here in 1879, and his widow, Mrs. B.C. Hale, is listed as this house's owner by the early 1900s. No Hales are listed here in later directories.

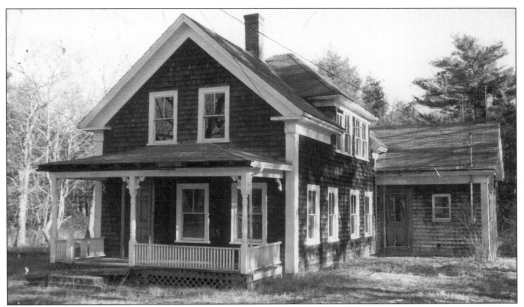

306 WAREHAM ROAD. The residence at 306 Wareham Road was built *c.* 1850. It is an L-shaped Greek Revival cottage with an 1880s to 1890s Queen Anne front porch addition. This home may have been built as a retirement home for Captain Hale, who is listed as its owner on the 1879 Marion map. The 1903 Marion map lists Mrs. B.C. Hale as its owner. No Hales are listed here in later directories.

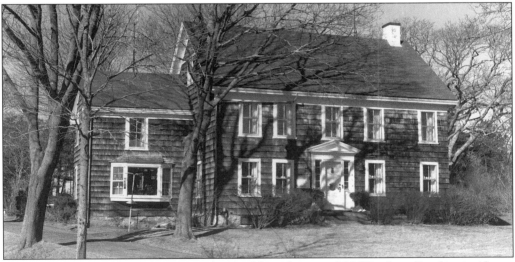

319 WAREHAM ROAD. Built *c.* 1800, the Washburn house at 319 Wareham Road is significant because it was one of the first two-story houses built in Marion. Wareham Road (Route 6) existed as a Native American coastal trail for centuries before the first English settlement was established in Marion in 1679. This home was built for Marion's Washburns, who have lived in town since at least the mid-18th century. Isaac and Japhet Washburn served as privates in Marion's company of Minutemen, responding to the first call-to-arms at Concord on April 19, 1775. The Washburn house was originally part of a large farm. The Washburn family continues to own and occupy this home today.

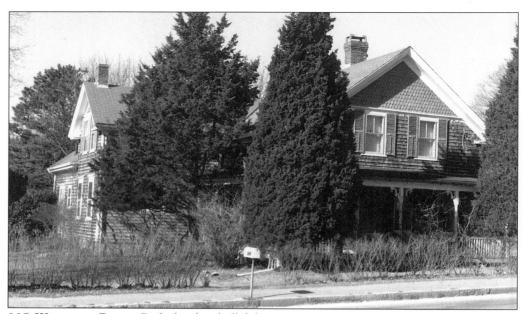

325 WAREHAM ROAD. Built for the shell fisherman Augustus M. Chase around 1879–1900, 325 Wareham Road is a modest, cottage-scale Queen Anne residence. Chase's residence, opposite Little Neck, was a prime location for a shell fisherman, as the coves and creeks on either side of Little Neck, including Briggs Cove, were historically rich in oysters and scallops. Reportedly, one of the features that attracted English settlers to Marion in the late 17th century was the abundance of oysters.

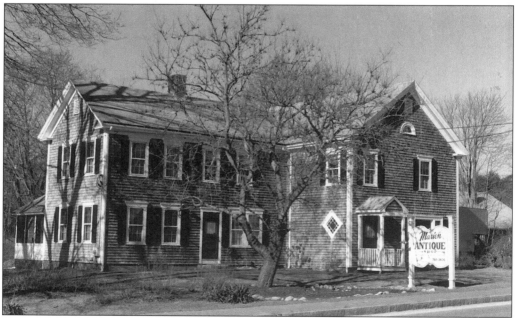

335 WAREHAM ROAD. The Italianate and Queen Anne dwelling at 335 Wareham Road was built between 1880 and 1900 for Seth Faunce, whose occupation was listed as a clerk and gardener. This building currently houses an antique shop.

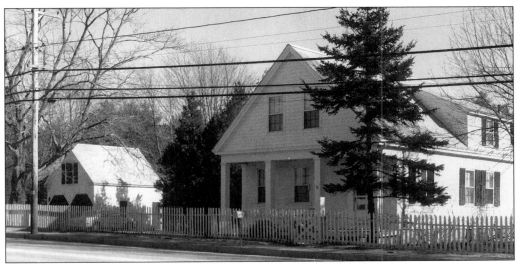

336 WAREHAM ROAD. The 1840s cottage at 336 Wareham Road is situated almost directly on Wareham Road, its front yard having been drastically reduced in size as the result of street widening. Although fairly common in other Massachusetts communities, this is the only example of a Greek Revival house with an overhanging attic in Marion. By 1855, Moses H. Swift, a merchant, lived here. By 1879, this property belonged to local real estate magnate, George Delano. He presided over an estate called the Hermitage at Little Neck during the late 19th century and owned much of Allen's Point during this period. In the early 20th century, C.H.L. Delano owned this house.

418 FRONT STREET. The Rev. Oliver Cobb area is located between the intersection of Front and Spring Streets (to the south) and Route 195 (to the north). Historically, this area is important as the neighborhood of the Cobb family of Congregational ministers. The home at 418 Front Street was built *c.* 1850 for Capt. John K. Hathaway. Essentially Greek Revival in style, the steep pitch of its gables also shows Gothic Revival elements.

429 FRONT STREET. The oldest home in this area is the late Georgian residence at 429 Front Street. The earliest known inhabitants of this house were members of the Hammett family. Mrs. H. Hammett lived here in 1855. By 1879, Robert W. Hammett, a farmer, owned this property. He was the First Warden of Marion's Independent Order of Odd Fellows at the time of their organization in 1845. In 1903, West Luce owned this property.

438 FRONT STREET. The Greek Revival and Italianate cottage at 438 Front Street was built between 1865 and 1870. Daniel Gallienne, who for many years was a flagman for the Cape Cod Railroad, lived here with his large family. In 1903, Emma L. Gallienne (a school teacher), Peter Gallienne, ("nursery stock"), Sophia Gallienne (a dress maker), and Daniel Gallienne all lived here. An August 30, 1917 *Wareham Courier* article entitled "Golden Wedding Celebrated by Mr. and Mrs. Daniel Gallienne of Marion," refers to this home as "Maplewood Cottage."

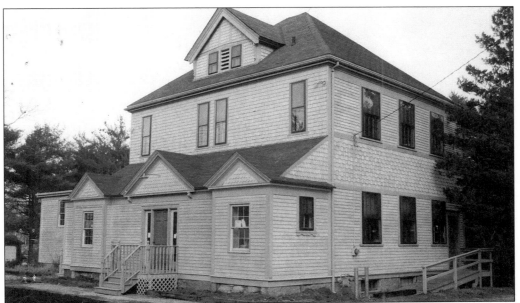

443 FRONT STREET. GRANGE HALL. The building at 443 Front Street was built between 1879 and 1900 in the Greek Revival and Italianate styles as North School. The 1903 Marion map shows a small rectangular structure surrounded by narrow yards. Later, the building was enlarged to become the Marion Grange. The Grange movement was started in 1867 by Patrons of Husbandry, an association of farmers that was organized in the United States in 1867 for mutual welfare and advancement. Grange halls became a familiar part of rural America by the 1880s.

444 FRONT STREET. The 1830 home at 444 Front Street is an interesting hybrid of the Federal and Greek Revival styles. This two-and-one-half-story home has the end wall gable facing the street, which is typical of the Greek Revival style. By 1855, master mariner James H. Pitcher owned this house. Pitcher's heirs owned the property in 1879. By 1903, Mrs. Justus Briggs was listed as the owner.

460 FRONT STREET. Built in 1799, the large late Georgian residence at 460 Front Street was built for the first minister of Marion's first Congregational Church, Rev. Oliver Cobb. The generous size of this house reflects Rev. Cobb's standing within the community. This house, which is set back and faces an ample lawn, is a rare late 18th-century Marion example of a two-story house at a time when one-story Capes were the predominant building type.

466 FRONT STREET. The Greek Revival cottage located at 466 Front Street was built between 1830 and 1850 for the teamster Edward W. Cobb. It was later owned by Lucretia M. Coffin, the widow of William B. Coffin. Mrs. Coffin lived here with Ansel G. Coffin until at least the mid-1920s.

Six

NORTH MARION

COUNTY ROAD AND
NORTH FRONT STREET

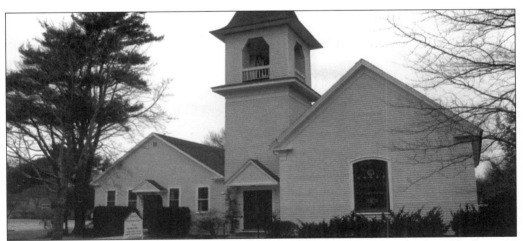

13 COUNTY ROAD. MARION METHODIST CHURCH. The Marion Methodist church at 13 County Road, an example of Italianate design, was built in 1865–1866. It occupies the site of an earlier church built in 1834 known as the Methodist Protestant Church. The first minister was Rev. Calvin Cummings. The second pastor, Rev. Nathan S. Clark, lived nearby at 536 Front Street. Later ministers included N.W. Britton and R.H. Dorr. In 1866, this church became known as the Methodist Episcopal Church and Rev. Able served as its minister for only one year. Later ministers include D.J. Griffin (1867–1869), N.W. Chase (1870), J.B. Washburn (1872–1875), Fred Upham (1875–1876), E.W. Culver (1877–1878), T.B. Gurney (1879), Samuel McKeown (1880–1881), Daniel M. Rogers (1882), and J. Lincoln Litch (1883–1884).

82 COUNTY ROAD. The Greek Revival home at 82 County Road is located in the area in North Marion that was called "Happy Alley." Built between 1840 and 1855, it was owned in 1855 by Ezra S. Parlow, a miller who operated a mill on the pond across the street from this house. During the mid-1880s, Parlow served as treasurer of Marion's Pythagorean Lodge, which was organized in 1861. The 1879 Marion map lists this home as owned by Nathan D. Parlow, who operated Nathan Parlow and Sons Grist Mill. In 1903, it was owned by Freeman F. Gurney, who resided at 202 Spring Street and operated a grocery store across from the depot.

137 COUNTY ROAD. The Cape Cod cottage at 137 County Road was built in 1762 and, in 1855, was owned by G.W.K. Pierce. In 1867, it was owned by Rufus L. Savery, a mariner, who by the early 1900s conducted a vegetable market and fruit stand on this property. By 1903, Rufus L. Savery was living here with his sons, Rufus H. and Charles. Savery's obituary in the *Wareham Courier* (April 23, 1909) notes that Savery was the town's herring inspector. He was an attendee at town meetings where he represented the interests of his North Marion neighbors. He was active in the Marion Methodist Church. Charles L. Savery, a gardener, inherited this house, where he lived with his wife, Iva, until 1930.

391 County Road. The home at 391 County Road is said to have been a wheelwright's shop. Around 1830, it was enlarged into a Greek Revival cottage to become the residence of Oren Vose, a farmer. Oren Vose was probably related to a leading family doctor in Wharf Village in the late 19th century, Dr. Albert C. Vose of 45 Main Street. Oren Vose lived in the house on County Road until at least the mid-1850s. Benjamin F. Vose operated a garden market and poultry farm on this property from the 1870s until his death on May 7, 1926.

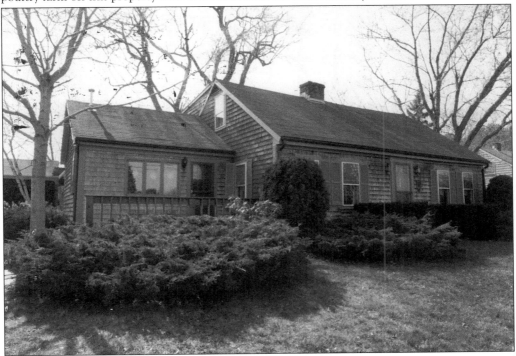

536 Front Street. The Cape Cod cottage at 536 Front Street was built in the first quarter of the 19th century. The 1855 Marion map lists the owner of this home as Rev. Nathan S. Clark, the second minister of the Marion Methodist Church. The 1879 and 1903 Marion maps indicate that this was the residence of Andrew Haskell.

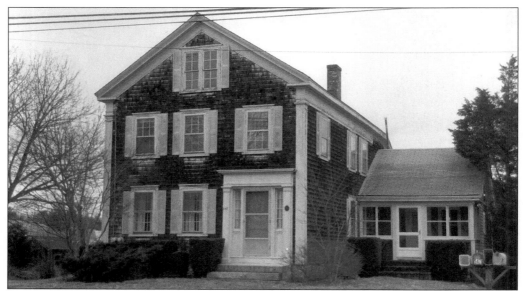

547 FRONT STREET. The 1840s Greek Revival dwelling at 547 Front Street was built by and for Paul W. Briggs, a carpenter. He served on the first board of selectmen for Marion, assuming this role shortly after Marion broke away from Rochester and was incorporated in 1852. By 1867, Paul W. Briggs, along with Howard and William Briggs, are listed as three of the seven carpenters and builders in Marion. Paul W. Briggs died on May 12, 1918 and his widow, Betsy, owned this house until 1926. The Briggs family of Marion is descended from Samuel Briggs, who had settled on Little Neck in Marion by the early 1700s. A large, well-known family in Marion, there were 27 Briggses listed in the 1867 Marion directory.

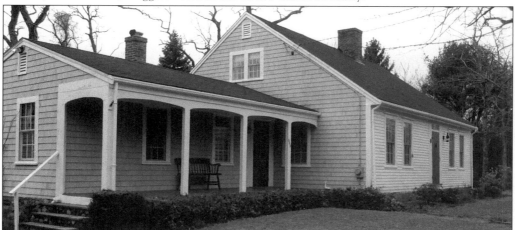

586 FRONT STREET. The home at 586 Front Street is a one-and-one-half-story Cape built in 1758–1759 for Benjamin Dexter, a blacksmith. From the late 18th century until the 1960s, five generations of Dexters lived here. Benjamin Dexter's ancestors were among the founders of the first church in Marion, with Thomas and Benjamin Dexter included on the roster of the 17 original male parishioners. In 1855, Rufus Dexter owned this property. By the 1880s, Seth Dexter, a dairy farmer, owned this property. He was a distributor of milk to the homes of Marion via a horse-drawn vehicle adorned with painted lettering that read "Locust Farm." By 1926, Lena and Robert Dexter, a machinist, owned this property.

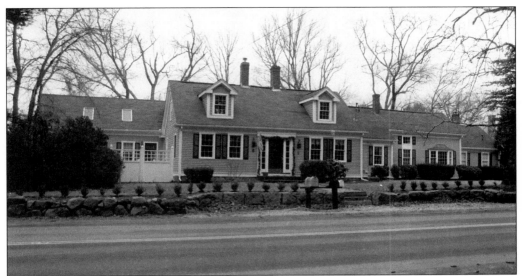

599 FRONT STREET. The nucleus of the dwelling at 599 Front Street is a Cape that was built c. 1830. Over time, extensive wings have been added to the rear and side walls. Currently known as Piney Woods Farm, its owner in 1855 was Stephen Clifton according to the Marion map. In the 1867 Wareham directory, Jonathan Ryder, a farmer, was listed as owner. By 1879, the heirs of J. Ryder (possibly John C. Ryder) owned this property. In 1903, William T. Briggs, a farmer, owned this property.

639 FRONT STREET. The home at 639 Front Street is located in the northwestern part of Marion near the Rochester line. Originally, the northern part of this property sloped down to Benson's Brook, a tributary of the Sippican River. This house was built before 1802 for Capt. Stephen Hammond. In 1802, Captain Hammond moved to 41 Main Street in Wharf Village. This house remained in the Hammond family, as the 1855 and 1879 Marion maps indicate that Stephen Hammond, listed in the 1887 Plymouth County directory as a carpenter, owned it. By 1903, Miss L.R. Hiller was listed as owner.

659 FRONT STREET. The home at 659 Front Street is a Colonial Revival interpretation of a Cape Cod Cottage. For most of the 19th century, its land was part of Obed Clifton's property. Clifton's farmhouse was located on the east side of the Sippican River, a few yards to the rear of 659 Front Street. This house does not appear on the 1879 Marion map, but is shown on the 1903 map. By the early 1900s, Jacob B. Savery, a laborer, owned this property. This home is architecturally significant as a late-19th-century interpretation of the Cape Cod house type.

714 FRONT STREET. Built before 1800 for Wing Hadley, the home at 714 Front Street is the last house in northwest Marion. It originally stood on a lot across the street and was moved to its present site in 1825 by Wing Hadley's son, Amos, who was a farmer. Just to the north of this house, a meandering tributary called Doggett's Brook serves as a boundary line dividing Marion from Rochester. A branch of the Sippican River, Doggett's Brook is called "Muddy Brook" and "Ventur's Brook" in old records and was known for its large trout. Members of the Hadley family lived here until at least the late 1870s. After 1880, Hadley's heirs sold this property to John Delano, a game commissioner who lived in this home until at least 1907.

Seven

WATER STREET

2 LEWIS STREET. Water Street may have begun as a Native American trail. Known as Harbor Lane at the turn of the century, it developed into an elite summer enclave in the late 19th and early 20th century. Built in the 1890s, the one-and-one-half-story, Shingle-style cottage called Point Rock Cottage at 2 Lewis Street overlooks Sippican Harbor. It is situated at the intersection of Lewis and Water Streets. David W. Lewis, a building-materials magnate, resided here until the early 1910s. His company, located in Boston, sold "Akron Sewer Pipe and Land Tile, Fire Brick, Chimney Tops, Chimney Flue Linings and F.O. Norton's Rosindale and Portland Cements."

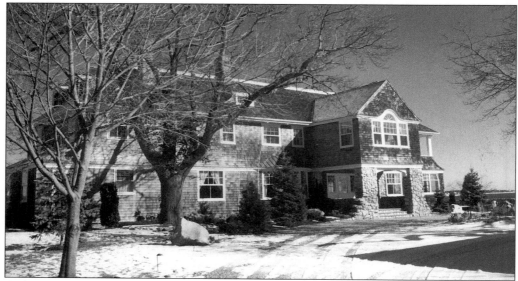

ONE WATER STREET. The Shingle-style home at One Water Street was built in the early 1890s as a summer residence for George P. Hamlin. Together with his brother, Edward Hamlin, who built a summer residence at 23 Water Street, they owned the Metropolitan Coal Company in Boston. They were cousins of Abraham Lincoln's vice president, Hannibal Hamlin of Bangor, Maine. This waterfront home was designed by the Boston architect William Gibbons Preston. Preston designed the Museum of Natural History on Berkeley Street in Boston, the first Massachusetts Institute of technology building (later demolished), and the Hotel Vendome in Boston. He also designed his own summer home in Marion, along with commissions for Tabor Academy, the Music Hall, and the Congregational Church.

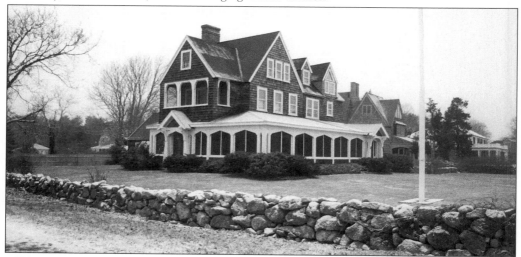

4 WATER STREET. Surrounded by fieldstone walls, the Shingle-style houses at 4 and 8 Water Street originally constituted a single large residence that was built in the 1890s for Frederick Cutler. Still substantial as separate houses, their designs exhibit characteristics of the Medieval, Revival, and Craftsman styles. These asymmetrical, wood shingle-sheathed houses are characterized by multiple gables, tall corbeled brick chimneys, and projecting and recessed porches.

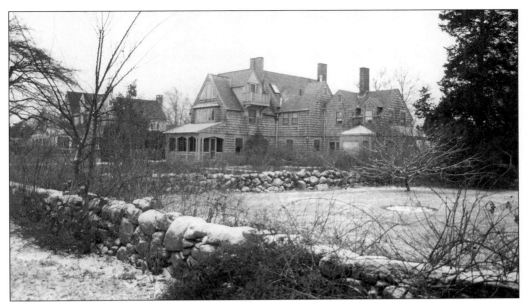

8 WATER STREET. This home was originally combined with 4 Water Street into one large summer residence.

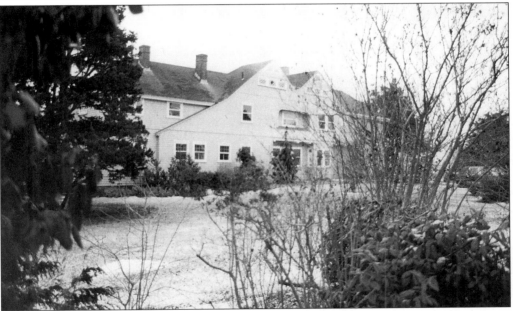

11 WATER STREET. The Shingle-style home at 11 Water Street was built in 1894 for attorney Richard S. Dow, who owned this house until at least the late 1920s. His law office was located at 27 State Street in Boston. During the early 20th century, he resided in the Back Bay at 295 Commonwealth Avenue. This house, along with the Austin home at 75 Water Street, suffered considerable damage during the hurricane of 1938. A *Wareham Courier* article dated September 27, 1938 noted that "the beautiful estates of Miss Edith Austin and of Richard S. Dow suffered unestimated damage when verandahs, boat houses and garages were demolished and the first floors of the main houses were wrecked."

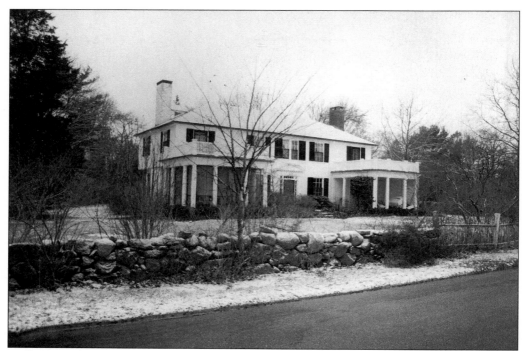

14 WATER STREET. Built between 1903 and 1920, the Williams-Cutler home at 14 Water Street ranks as one of Marion's finest examples of a Colonial Revival residence.

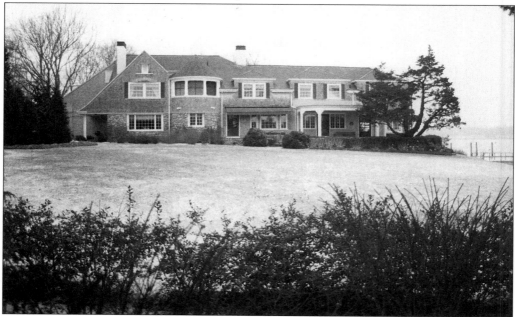

23 WATER STREET. The Shingle-style house at 23 Water Street was built in the early 1890s for Edward Hamlin. Designed by Boston architect William Gibbons Preston, this lovely home is sited to overlook Sippican Harbor and an ample south lawn. The lawn's Water Street side is enclosed by a low rubble stone wall.

23 WATER STREET BOAT HOUSE. Near the southern extremity of this wall is a delightful boat house. Another charming and whimsical outbuilding, the "Thinking Cottage" guest house, is located on the north side of the property overlooking Sippican Harbor.

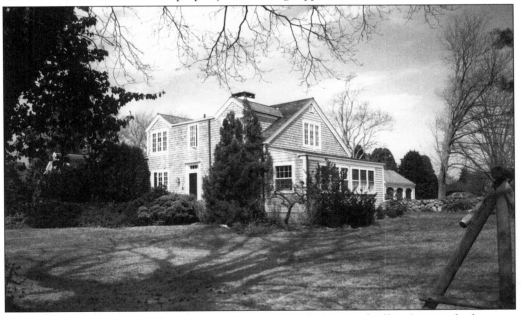

ONE ALLEN STREET. Located at the northwest corner of Water and Allen Streets, the home at One Allen Street evolved from a small Queen Anne cottage that has been altered over the years. The dwelling was built in 1885 as the summer home for Rev. John Brooks, who was the rector of Christ Episcopal Church in Springfield. His brother, Rev. Phillips Brooks, was a frequent summer visitor. Rev. Phillips Brooks, the rector of Trinity Church in Boston, is well known for writing the Christmas hymn "O Little Town of Bethlehem." Their mother was related to the Phillips family, founders of the two famous Phillips Academies in Andover and Exeter.

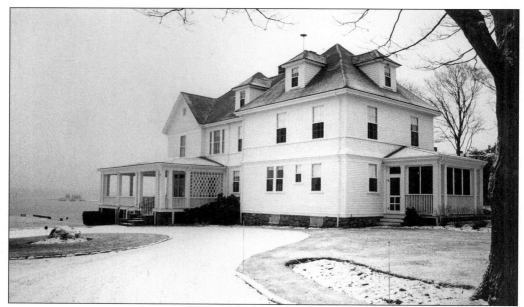

35 WATER STREET. Built between 1903 and 1910, the Queen Anne and Colonial Revival house at 35 Water Street is one of the few houses in this area that does not reflect the influence of the Shingle style. It was purchased on October 31, 1912 by Henry P. Kendall of Norwood, Massachusetts.

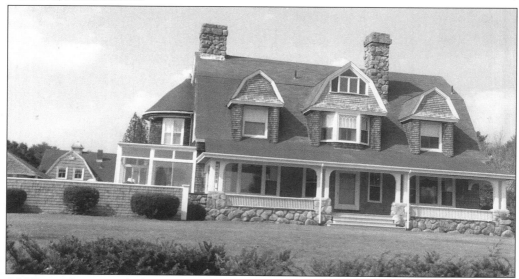

46 WATER STREET. The home at 46 Water Street evolved from an early-19th-century dwelling owned by the salt industry entrepreneur Ebenezer Holmes (1783–1869). In 1870, this home was inherited by one of Ebenezer Holmes's daughters, Mary, the wife of George W. Kelley. The property was purchased in 1892 as a summer home by Henry R. Reed of Boston. Reed added a large Shingle-style addition to the front and, to the rear, a barn-stable that was designed by the Boston architect James Kelley. This house was a summer residence of President Grover Cleveland and his wife. The president particularly enjoyed fishing in Buzzards Bay. They both became so enamored of the town that they named one of their daughters Marion.

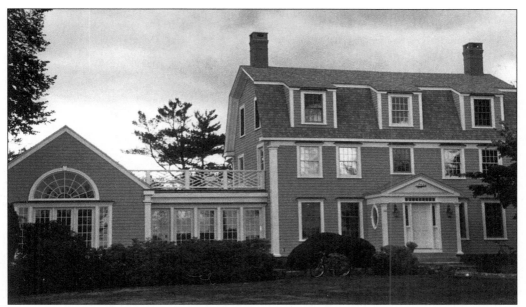

60 WATER STREET. The Federal style home at 60 Water Street was built in either the late 18th or early 19th century for Capt. Henry Allen, who was associated with Marion's salt industry, ship building, and the coastal schooner trade. Captain Allen—along with George Bonum Nye and Ebenezer Holmes—was a pioneer in Marion's production of salt, which was manufactured by the evaporation of saltwater. Although the British taxation of salt ceased in 1815, Marion's salt industry continued until the Civil War because of its efficient means of producing salt, which was necessary for the preservation of fish. Additionally, Capt. Henry Allen built whalers in his shipyard, once located across the street from his house.

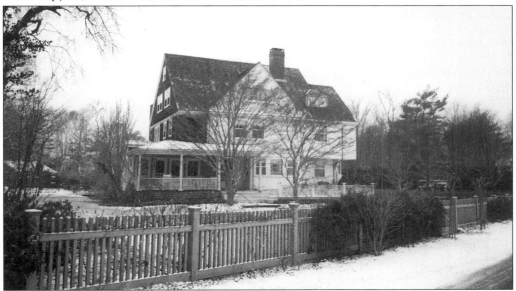

72 WATER STREET. The Green House at 72 Water Street is a Queen Anne- and Shingle-style residence built around 1890 for George U. Crocker, an attorney and treasurer for the City of Boston. He resided in this house until 1920.

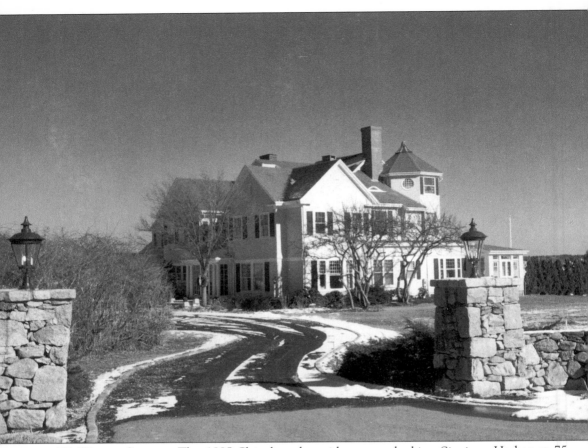

75 WATER STREET. The 1885 Shingle-style residence overlooking Sippican Harbor at 75 Water Street was designed by architect William Gibbons Preston for Judge J. Whitney Austin. Judge Austin lived at Bigelow Hill in Brighton, Massachusetts, during the winter. He was a partner of the Boston firm of Austin and Graves, "manufacturers of Austin's Dog Bread and all kinds of Crackers and Ship Bread," located at 116 Commercial Street in Boston. After Austin's death on October 4, 1902, the house was inherited by his widow. By 1916, this house was owned by Edith and Herbert Austin. Herbert died on March 22, 1925.

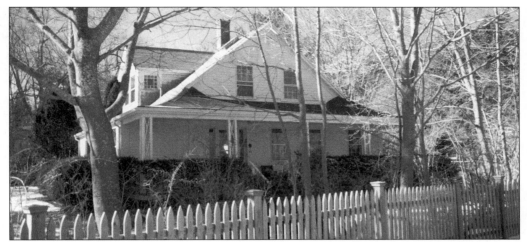

80 WATER STREET. Built in 1823, the house at 80 Water Street was originally located near the Old Parsonage at 113 Front Street. It was built for Samuel and Charity Waters, who together with their four children immigrated to Massachusetts from England. This cottage was moved to the northwest corner of Vine and Water Streets in 1866. For many years, the Bayview House (later Sippican Hotel) was its neighbor to the north. Later owners included the Barrows heirs (1879) and Mrs. P.P. Lovett (1903). The Boston architect William Gibbons Preston provided designs for this cottage's alterations during the early 1880s.

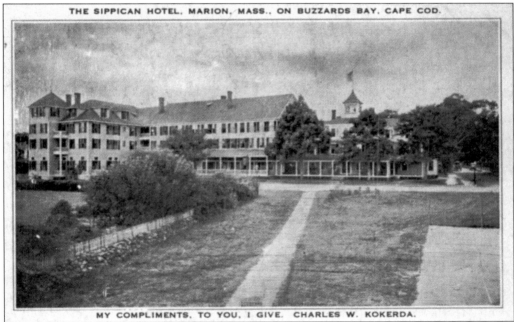

THE SIPPICAN HOTEL, MARION, MASS., ON BUZZARDS BAY, CAPE COD.

MY COMPLIMENTS, TO YOU, I GIVE. CHARLES W. KOKERDA.

THE SIPPICAN HOTEL. This postcard shows the Sippican Hotel, which was located on the site of present-day 88 Water Street. Many of Marion's summer visitors stayed at the Sippican Hotel. Henry James described this hotel in *The Bostonians* (1886) as "a shabby and depressing hostelry that suggested an early bed time." However, many of the hotel guests fell in love with Marion and subsequently built large Shingle-style summer residences in Marion. It was torn down in the 1920s.

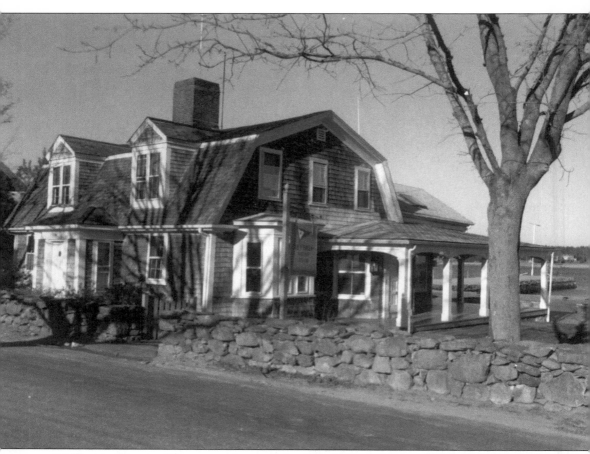

99 WATER STREET. The current home of the Beverly Yacht Club at 99 Water Street was built in 1806 as a ship chandler's store because of its location near Sherman's or Central Wharf (later called Long Wharf). Long Wharf was "much frequented by whalers" and was the home of Marion's last whaler, the *Admiral Blake*, the final voyage of which marked the end of the whaling era in the 1880s. Later, this structure became Sherman's Inn, a stagecoach stop on the Wareham-to-New Bedford route. In the 1870s, this building became the summer residence of Adm. Andrew A. Harwood, whose daughter, Bessy, encouraged Richard Watson Gilder, the editor of *Century Magazine*, to summer in Marion. A great-grandson of Benjamin Franklin, Harwood was invited in 1871 by Joseph Snow Luce, proprietor of the nearby Bay View House Hotel, to conduct Episcopal services for his summer guests. Admiral Harwood was the first rector of St. Gabriel's Episcopal Church in Marion. Owned by Harwood's heirs in the early 1900s, it became the summer residence of Dr. William McDonald during the 1920s. Franklin D. Roosevelt sought Dr. McDonald's medical expertise after contracting polio in 1921 and often visited him in Marion. In 1955, this property was acquired by the Beverly Yacht Club.

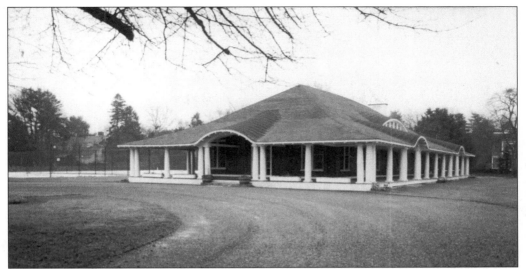

20 HOLMES STREET. The other non-residential building of architectural significance in the Water Street area is the stucco and wood Sippican Tennis Club at 20 Holmes Street. It was designed in the Mission Revival style by the prominent Boston architect Charles Allerton Coolidge in 1908. Flanked by tennis courts and overlooking a semi-circular driveway, it is a remarkable survivor from the Edwardian era. It also exhibits characteristics of the Craftsman and Classical Revival styles.

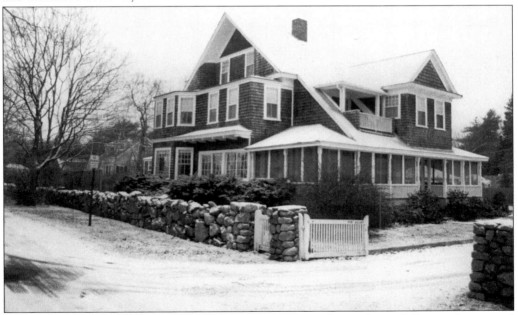

2 PIE ALLEY. The Water Street area also encompasses the enclave of Queen Anne- and Shingle-style houses known as Pie Alley, an unpaved way enclosed by wooden slat-work gates and bordered by four houses. Three of the homes were built in the 1890s as a real estate development project by Benjamin A. Waters. Waters was the owner of Marion Gas Works, which was located in the Old Stone Studio after the Gilders' ownership ended. The home at 2 Pie Alley is one of Marion's more compact examples of a Shingle-style residence.

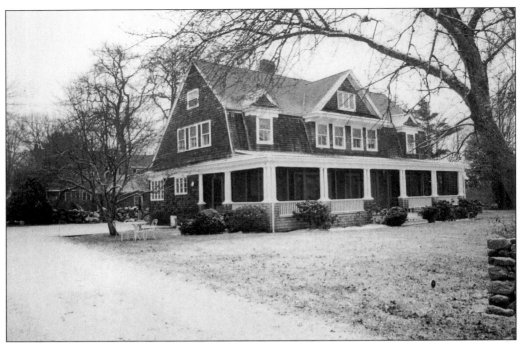

9 PIE ALLEY. The Shingle-style home built at 9 Pie Alley by Benjamin A. Waters is deeply set back from Lewis Street and faces an ample lawn. Entirely sheathed in wood shingles, a full-length porch projects from its Lewis Street facade. It is enclosed by slat-work railings.

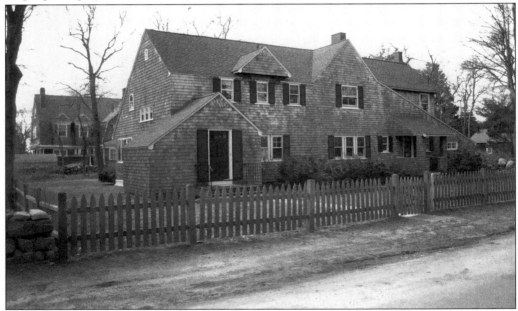

6 ALLEN STREET. Situated at the northeast corner of Pie Alley and Allen Street, the 1890s home at 6 Allen Street was built for Augustus Nickerson. Although it is Shingle style by design, it also has English Medieval Frame influences. The home is L-shaped, exhibiting horizontal massing and weathered wood shingles.

Eight

ALLEN'S POINT ROAD AND WEST DRIVE

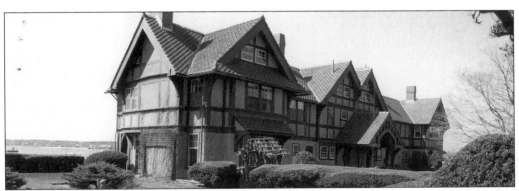

125 ALLEN'S POINT. Until as late as 1890, Allen's Point was a remote, undeveloped part of Marion. By the mid-19th century, Allen's Point was part the Henry D. and Stephen Allen's holdings. Their homes were located on the west side of Point Road, near its intersection with Cross Neck Road, but they no longer exist. The Allens were farmers. Henry D. Allen was one of Marion's first three selectmen in 1852–1854. At some point between 1855 and 1879, the Allens sold Allen's Point, the West Drive area, and other tracts south of Point Road to George Delano. The lovely summer estate of Edward M. Clark at 125 Allen's Point Road was designed by the Boston architectural firm of Coolidge and Carlson. It was built in the early 1900s. Among Coolidge's best-known works were Byerly and Randolph Halls (at Radcliffe and Harvard respectively), dormitories at Wellesley College, and the Bates College Library in Lewiston, Maine. This home is the finest example of Tudor Revival domestic architecture in Marion. Outbuildings include a stable, garden house, and boat house. Edward M. Clark commissioned the Boston landscape architect Arthur A. Shurcliff, a student of Frederick Law Olmsted, to design the south garden and the estate's grounds. His best-known landscape work was in Colonial Williamsburg. Clark sold the property to Richard Hoyt, whose daughter, Virginia Pierson, inherited the property from her parents.

STABLE. On the north side of the driveway, leading westward from Allen's Point Road, is a substantial Tudoresque stable that matches the main house.

GARDEN HOUSE. A one-story stucco garden house encloses the east side of the garden.

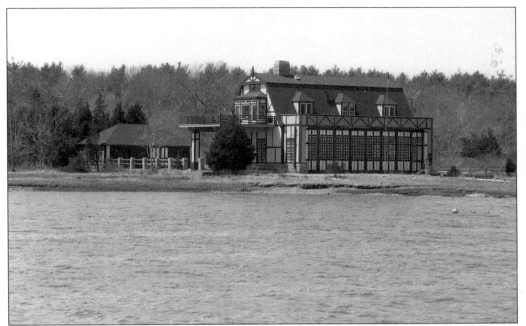

BOAT HOUSE. The boat storage facility is another ancillary building located on Blankinship Cove's eastern shore. The building was originally built as a hanger for a seaplane and was then converted for boat storage.

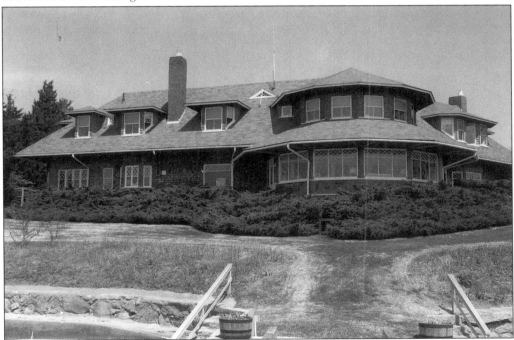

151 ALLEN'S POINT ROAD. The lovely Shingle-style home at 151 Allen's Point was built in the early 1900s for the Boston physician A. E. Angier, who was listed at this address until about 1907.

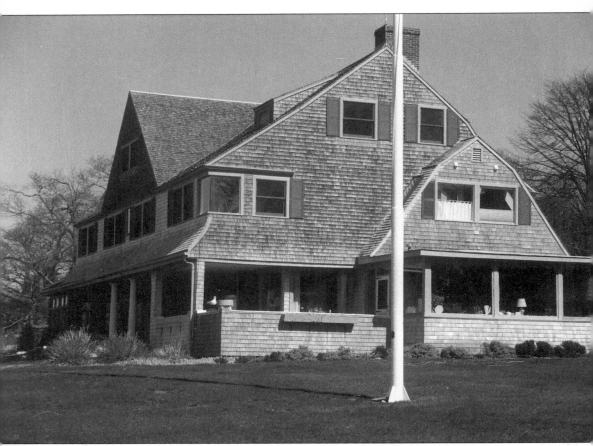

2 WEST DRIVE. West Drive encompasses five lovely Shingle-style residences located on Sippican Harbor. Bearing evocative names such as Cedarholm, Merry Court, Stony Croft, and Hazelmere, this enclave's residences are surrounded by rolling lawns dotted with rock outcroppings. To the rear of these houses are circular driveways and wooded areas. This area illustrates the popularity of the Shingle style used for the substantial summer residences in New England coastal communities during the 1880s and 1890s. The handsome Shingle-style cottage at 2 West Drive may be the oldest residence within the enclave. Built in 1893 for the Boston leather dealer, William M. Bullivant (1858–1939), this home was designed by Charles Allerton Coolidge. In 1900, Bullivant founded the Northwestern Leather Company and served as its president until his retirement in 1921. Over time, Bullivant was able to acquire 450 acres of land at Great Neck, including the grounds of what is now the Marion Golf Club. The golf course and the gardens at this home were designed by George C. Thomas Jr. of Philadelphia, who summered on the Cape. A noted collector of art and rare books, Bullivant possessed one of the finest collections of etchings in the country. His library, though small, contained many rare books. For many years, he was a vestryman of St. Gabriel's Episcopal Church in Marion. He also belonged to numerous Boston clubs, including the Algonquin and Exchange Clubs, the Club of Odd Volumes, and the Iconogaphic Society.

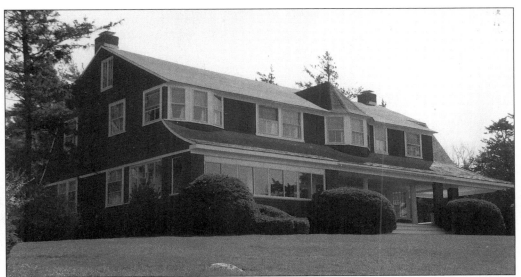

8 West Drive. Designed by Coolidge and Carlson, the house at 8 West Drive, was called Merrycroft. It was built for Charles W. Leatherbee, who was the proprietor of the Leatherbee Lumber Company of Roxbury, Massachusetts. Leatherbee was a summer resident of Marion until 1910.

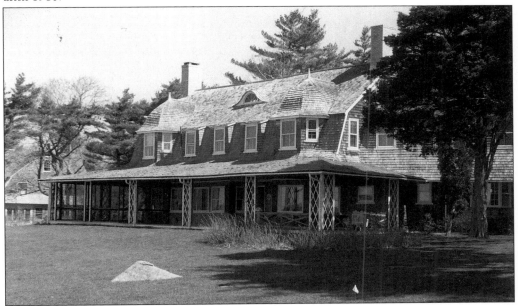

14 West Drive. Stonycroft at 14 West Drive exemplifies the Shingle style at its most picturesque. It was also designed by the architectural firm of Coolidge and Carlson and built for Brookline resident A.W. Bliss, whose leather business was located in the heart of Boston's leather district. Its landscaping complements an architectural design that delicately balances rustic and formal qualities. Exterior and interior photographs of the Bliss House appeared in the October 29, 1919 edition of the *American Architect*, showing Craftsman style furniture within. It also showed rustic interiors with low ceilings, exposed timbers, and both stone and brick fireplaces.

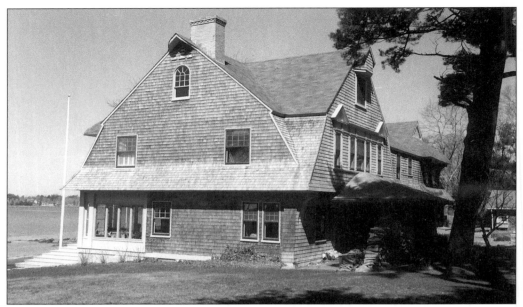

24 WEST DRIVE. The Shingle-style home at 24 West Drive was named Cedarholm. It was designed by Coolidge and Carlson for the Boston stockbroker Charles W. Butterfield, whose firm, Tower and Underwood, was located on Devonshire Street in Boston. Butterfield lived in Chestnut Hill during the winter months and spent summer vacations in Marion until the early 1920s. In this house, the architects have skillfully blended the Shingle-style materials with Queen Anne and Colonial Revival elements. Interior and exterior photographs appeared in the October 1904 issue of the *House Beautiful*, showing Mission-style furniture and a fireplace of boulders.

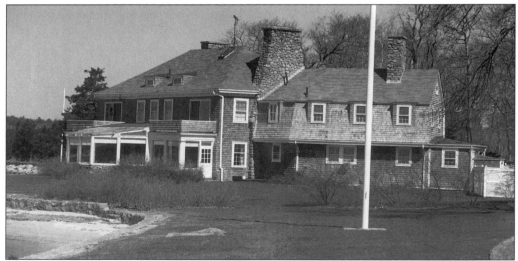

28 WEST DRIVE. The northernmost house in this group at 28 West Drive was built for Charles W. Leonard. It was also designed by Coolidge and Carlson. Leonard was a prosperous proprietor of a woolens business called Holden, Leonard and Company. Leonard, a resident of Newtonville for many years, is last listed as a Marion summer resident in the 1910–1911 Wareham directory.

Nine

LITTLE NECK, SIPPICAN NECK, AND GREAT NECK

34 HERMITAGE ROAD. The house at 34 Hermitage Road is situated where the main Sippican Native Americans resided under the leadership of Chief Massasoit of the Wampanoag tribe. Nearby, at Minister's Rock, was the first settlement in Marion (then called Sippican), established when 29 families of Pilgrims left Plymouth in 1678. This Cape Cod cottage dates from the mid-to-late 18th century and may be that of Walter Turner, who is shown on the 1855 Marion map. By the late 19th century, George Delano owned this house. By 1903, it was owned by C.L. Delano. George Delano named this property the Hermitage. During the first visit of President and Mrs. Cleveland to Marion in 1887, George Delano offered the First Family the use of his beach because of its privacy and splendid views of Sippican Harbor.

62 Creek Road. Linking Wareham Road (Route 6) with Point Road, the path of Creek Road crosses Jenney's Creek midway between these thoroughfares. The home at 62 Creek Road is a good example of the Greek Revival and Italianate cottages commonly built between the 1840s and 1870s. This home was built between 1855 and 1879 for Ellen and James H. Marvel. He was a farmer from 1870 to 1926.

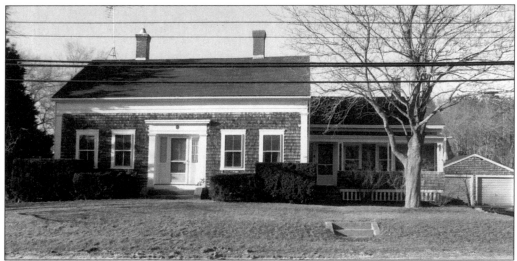

65 Creek Road. The home at 65 Creek Road is an example of a *c.* 1830s Cape with Greek Revival elements. By 1855, his house was owned by John Briggs, a descendant of a family that first settled on nearby Little Neck in the late 17th century. Over time, the Briggs family ranked among the most prolific in Marion, producing a large number of seafarers. In the 1867 Plymouth County directory, 27 male members of the Briggs family are listed. By 1879, Andrew Jackson, a mariner, lived at this address. Jackson's estate owned this property by 1903. His widow, Sarah M. Jackson, lived here until around 1920.

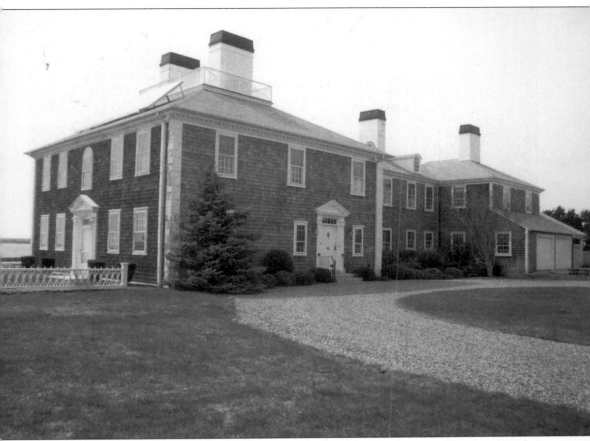

90 POINT ROAD. The home at 90 Point Road is sited between the shores of Sippican Harbor and a great bend in Point Road that defines the western edge of the Kittansett Club golf course. It ranks among the finest examples of the Georgian Revival style in Marion. It is situated near Ruggles Point, the southeastern-most section of Sippican Neck. The land was part Michael Haskell's (later Charles Ruggles') extensive land holdings in the mid-to-late19th century. Historically, Ruggles Point (formerly Butler's Point) was one of the most remote sections in Marion. East Road, later called Point Road, terminated at the old J.K. Briggs Farm (later called Macomber Farm) at 336 Point Road. Until the second decade of the 20th century, Ruggles Point could only be reached by a minimally maintained dirt road. An article in the *Wareham Courier* on August 21, 1910 discussed the need for a formally set out "drive to the sea [that would] provide the public with access to spectacular views of Sippican Harbor and Buzzards Bay." It was built in 1929 for the George family by the George Construction Company of Worcester.

336 POINT ROAD. The dwelling at 336 Point Road was the last home on Point Road until it was extended to Ruggles Point in the early 20th century. This Cape Cod cottage was built in the 1820s, and the earliest known owner was J.K. Briggs, who is identified on the 1855 Marion map. By the 1870s, a farmer named Caleb E. Macomber (1809–1893) owned this property. His son, Caleb Jr., farmed this property until around 1920.

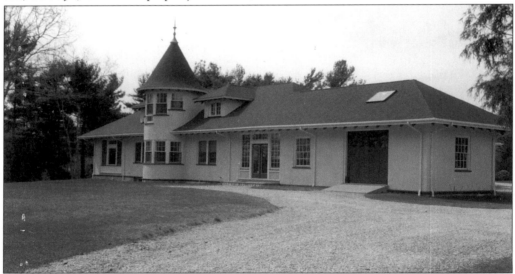

451 POINT ROAD. STABLE. The main house at 451 Point Road no longer exists. But the things that do remain—the secondary buildings, the noteworthy landscape elements, and an imposing stucco-covered, tile-capped terra cotta wall—attest to the original grandeur of this great estate. Along with the Queen Anne and Craftsman styles, buildings of this estate possess elements of the Mission Revival style. This estate was built for Arthur W. Hartt between 1899 and 1902. Hart is listed in late-19th- and early 20th-century Boston directories as a resident of Brookline and as a clerk working at 87 Milk Street, Boston. By 1916, Hartt was a permanent resident of Marion, living here until the early 1920s. The stable, which also served as staff housing, has been substantially renovated in recent years.

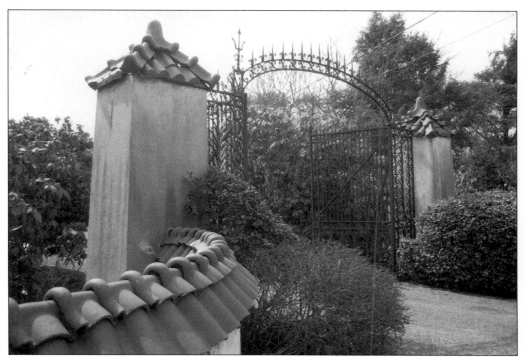

451 POINT ROAD. GATE. Rendered in the Mission Revival style, this wall, which runs the length of the Point Road edge of the property, is capped by terra cotta tiles. Interrupting the expanse of this wall is a center entrance that retains ornate iron gates. These gates are flanked by tall cast concrete piers, which culminate in pyramidal caps composed of terra cotta tiles.

451 POINT ROAD. BOAT HOUSE. A Mission-style stucco boat house, situated near the northwestern corner of the property, overlooks Planting Island Cove.

113

459 POINT ROAD. The house at 459 Point Road was built between 1898 and 1903. It ranks among the finest examples of the Shingle style in Marion. An extensive lawn sweeps westward to Blankinship and Planting Island Coves. This house was probably designed by Coolidge and Carlson, the Boston architectural firm that was responsible for a number of Shingle-style houses bordering West Drive in Marion. This home was built for Mrs. F.C. Bowditch.

501 POINT ROAD. Built *c.* 1780, the Cape Cod dwelling at 501 Point Road is the nucleus of the Ellis Neighborhood. During the mid-19th century, this house was owned by Stephen Ellis, a farmer. By 1879, his heirs are listed as its owners. During the early 1900s, it was owned as a summer residence by Hannah M. Ellis of New Bedford. Pegged beams, hand-wrought nails, and a small fireplace containing small English bricks are said to remain in southern part of the house. This home is still owned by the Ellis family.

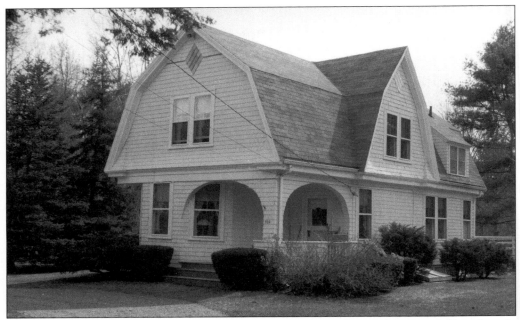

502 Point Road. Across the street at 502 Point Road is a Queen Anne- and Shingle-style house built between 1905 and 1910. The property was carved from the extensive holdings of Charles D. Ellis. This house is historically significant as a modest, inland version of the more substantial summer cottages that were being built near Marion's shores during the late 19th and early 20th centuries. This house was built at about the same time that Point Road was extended to Ruggles Point.

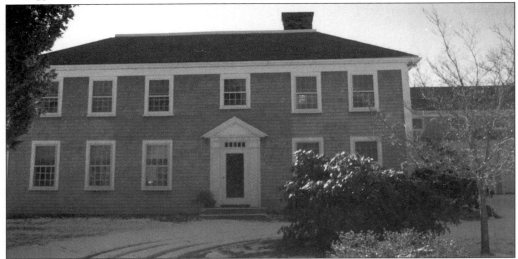

510 Point Road. The home at 510 Point Road is a substantial frame residence exhibiting the boxy, hip-roofed form of an 18th century Georgian residence. The origin of this house is unclear since it does not appear on the 1855 Marion map, an omission that could be a cartographer's error. By 1867, this home was owned by Charles D. Ellis, who was a farmer and one of two constables for Marion in the mid-1870s. By 1903, Charles D. Ellis, a laborer, lived here along with Catherine D. Ellis and Archibald W. and William H. Ellis, both carpenters.

116

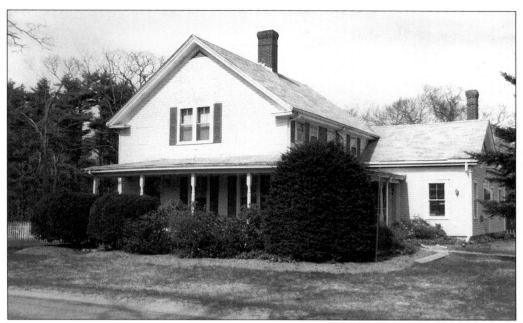

513 Point Road. The dwelling at 513 Point Road was built during the mid-19th century in the Italianate style. The house is prominently situated at the crossroads of Point and Delano Roads. Along with three other neighboring dwellings, the house provides an unspoiled glimpse of a rural, remote Sippican Neck before seasonal and suburban house construction transformed its appearance in the 20th century. The 1855 Marion map identifies the owner of this home as William Ellis. By 1879, George Hammond, a carpenter, owned this property. In 1903, this house was owned by Charles M. Ellis, whose occupation is variously listed as contractor and "teaming and jogging." He lived here until at least 1926.

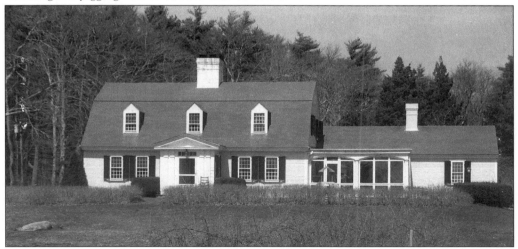

604A Point Road. The clapboard-clad Colonial Revival residence at 604A Point Road was built between 1895 and 1903. It was designed by the architect Charles Allerton Coolidge for his own family. He was a partner in the Boston architectural firm of Shepley, Bulfinch, Rutan and Coolidge, successors to the practice of Henry Hobson Richardson. This lovely home overlooks rolling lawns, while there is a wooded area behind it.

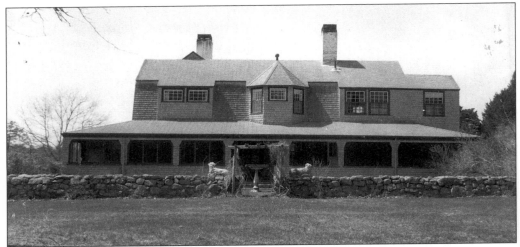

604B POINT ROAD. One of the finest examples of the Shingle style in Marion, 604B Point Road was initially designed and built in 1891 by Charles Allerton Coolidge for his own summer residence. In the early 1900s, Mr. Coolidge sold this home to the prominent I.H. Lionberger family of Westmoreland Place in St. Louis. Mrs. Lionberger was related to George Shepley, a partner in Shepley, Rutan, and Coolidge. George Shepley was married to Julia Richardson, the daughter of the great architect Henry Hobson Richardson. By the mid-20th century, Charles Allerton Coolidge Jr., the architect and original owner's son, owned this house.

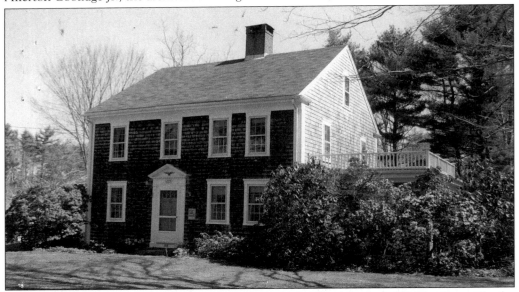

669 POINT ROAD. The Georgian home at 669 Point Road was built in 1825 by Capt. Charles Hammond for his daughter as a wedding gift. The Hammonds were descendants of Samuel and Mary Hammond, who were the founding members of the Marion 1703 church. The owner of the property, as listed on the 1855 Marion map, was C. Hammond. The Hammonds owned this property until c. 1890. During the 1890s, the house was purchased by William Bullivant (1858–1939), who moved to Marion in 1893. He subsequently acquired more than 450 acres of real estate in East Marion, including the Marion Golf Club. He possessed a fine collection of etchings and rare books.

675 Point Road. The early Cape Cod cottage at 675 Point Road was built *c.* 1820. The house was also owned by the Hammonds, the descendants of John and Samuel Hammond. They were among the 29 "substantial men" who formed the first permanent English settlement in Marion during the late 1670s. The Hammonds were also part of Marion's company of minutemen who responded to the call-to-arms at Lexington and Concord on April 19, 1775, marching from Rochester (Marion) to Boston in response to the Lexington call. In the early 1900s, Mrs. E.E. Hammond owned this home.

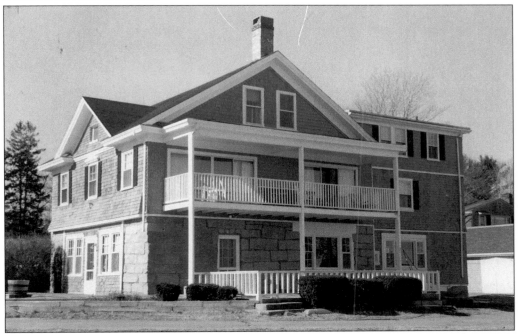

272 Delano Road. The home at 272 Delano Road was built between 1855 and 1875. It overlooks the mouth of the Weweantic River and is linked to Delano Road by a driveway marked by distinctive granite and rubble stone gate posts. This building does not appear on the 1855 Marion map. The 1879 map indicates that the property was owned by Mrs. Miles. By 1903, M.T. Andrew owned this property.

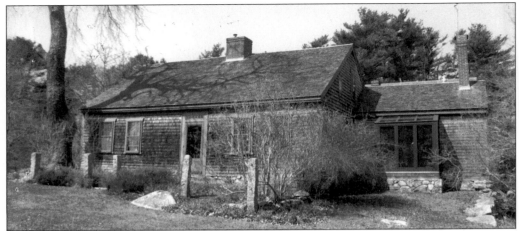

343 DELANO ROAD. The Cape at 343 Delano Road may date to the 18th century. This home was owned by the Benjamin Briggs family until the early 19th century. In December 1772, Samuel Briggs Jr. was a member of a committee of local men that supported and kept in touch with the patriots' activities in Boston. In March 1775, Nathaniel Briggs was among a group of local men chosen to see that local Minutemen were properly equipped for military duty. Capt. Josiah Briggs was the captain of the local company of Minutemen who responded to the call-to-arms issued from Lexington on April 19, 1775. John Briggs was one of the 40 privates in this company.

370 DELANO ROAD. The home at 370 Delano Road stands adjacent to Dexter's Landing on the shores of the Weweantic River. Built c. 1750, this Cape Cod home has significant historical associations with Marion's Dexter family, the descendants of Thomas Dexter who came to Plymouth, Massachusetts, from England in 1630. By the mid-19th century, this home was owned by T. Caswell. By 1879, it was owned by B. Dexter. In 1903, Mrs. B.F. (Olive M.) Dexter lived here with her son, Josiah Dexter, a jeweler in New Bedford. In 1926, Benjamin F. Dexter, a grocer, lived here. During the early 1900s, the famed mariner Capt. Joshua Slocum rented this home from the Dexters. He is famous for sailing around the world alone on a 37-foot boat called *Spray*.

Ten

DELANO AND CROSS
NECK ROADS AND
GREAT HILL

311 DELANO ROAD. Traversing Great Neck, Delano Road evolved from Native American trails. This section of Great Neck was settled by the Delano brothers at some point in the mid-18th century. The Delanos were an industrious family of farmers, fishermen, and early salt entrepreneurs. They were direct descendants of Philippe de la Noye, the first French Hugeunot to come to America in 1621 on the *Fortune*, which landed in Plymouth. The late-19th-century cottage at 311 Delano Road is enclosed on its Delano and Cross Neck Street sides by low rubble stone walls.

312 DELANO ROAD. Part of the charming cottage at 312 Delano Road was built *c.* 1750 by Harper Delano. The prominent Delano family—along with the Briggses, Dexters, and Ellises—were among the first families of Great Neck during the 18th century. A mold for making bullets for the War of 1812 was found in the basement of this house. During the War of 1812, the Delanos were well placed to witness barges carrying British troops from the *Nimrod* on their way to Wareham, where they burned a few houses in the village. By 1903, Amos Cornell owned this property. President Franklin Delano Roosevelt was related to the Marion Delanos.

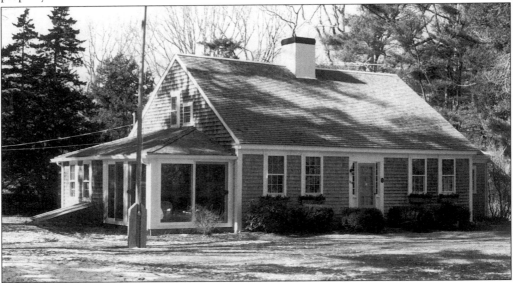

319 DELANO ROAD. The home at 319 Delano Road (Shore Farm) was built *c.* mid-18th century for Stephen Delano, whose extensive salt works along the Weweantic River on the north side of Delano Road were some of the first built in Marion. This typical Cape Cod house was owned by I. Delano in 1855. By 1879, Polly Delano lived here. By 1903, Capt. Charles C. Delano owned this home, remaining there until his death on April 18, 1916. Capt. Amos Delano, a member of the Marion Board or Selectmen, lived here until at least the mid-1920s.

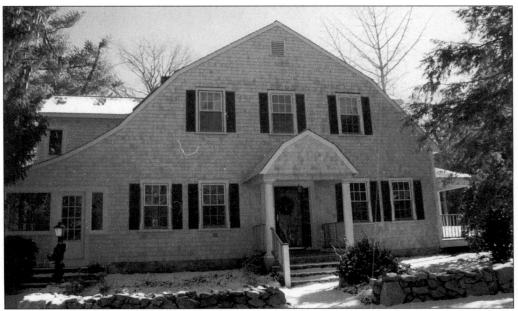

12 CROSS NECK ROAD. The Shingle-style residence at 12 Cross Neck Road was built for, and probably by the carpenter Thomas Hartigan before 1903. Hartigan's widow lived here until at least 1916.

GREAT HILL. IRON GATES. These beautiful iron gates lead to a large peninsula of rolling woods, meadows, and lawns on Buzzards Bay. The prominent feature of this estate is a distinctive glacial hill that reaches 127 feet above sea level and gives the estate its name.

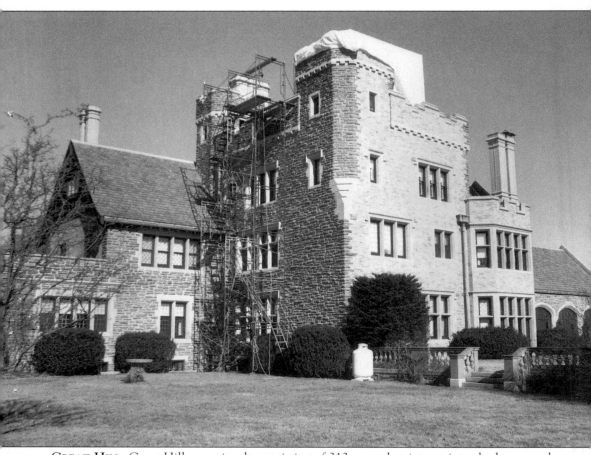

GREAT HILL. Great Hill, a peninsula consisting of 313 acres that jut out into the bay, was the site of Marion's first summer hotel, the Marion House, which accommodated 300 guests. Today, this estate encompasses the largest main house and the most extensive collection of ancillary buildings in the town of Marion. Native Americans relied on Great Hill's elevation as a strategic lookout to protect their families and crops. Great Hill also served as their sacred tribal meeting ground. In 1907, Galen Stone, a Boston investment banker, purchased the property. He demolished the hotel and hired architect Horace S. Fraser to design a rambling mansion built out of Hayden stone taken from the Philadelphia area. The family firm was called Hayden Stone, and thus the use of that type of stone. The Tudor manor house was copied from an estate north of London called Compton Wyngates. By 1911, the Stones moved into the massive summer "castle" with 30 servants. Another 20 male employees lived in a building on the grounds for the staff. Reduced in size by approximately four-fifths today, the residence is still a substantial stone and brick building.

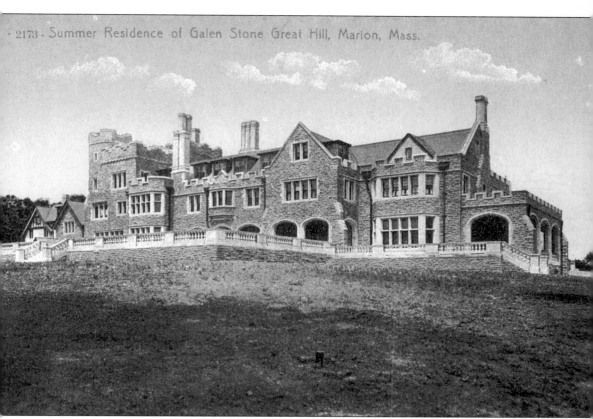

GREAT HILL AS ORIGINALLY BUILT BY GALEN STONE IN 1909–1911. Long before a permanent English settlement in Marion in 1679, Native Americans had their sacred tribal meeting ground at Great Hill. During King Philip's War in the 17th century, Great Hill was the scene of a peace accord between English troops and Queen Awashanks and her tribe. During the colonist era, salt hay was harvested here, and much of the acreage was used for pasturage for livestock. In 1860, Marion's first summer hotel, the four-story Marion House, was constructed on Great Hill. Around 1880, a wealthy Dedham resident, Albert Nickerson, bought the hotel after his family was asked to leave the hotel because his children had developed measles. By the early 1900s, John E. Searles of Newkirk City owned Great Hill as a summer retreat. Galen Stone built this summer "castle" after purchasing Great Hill in 1909.

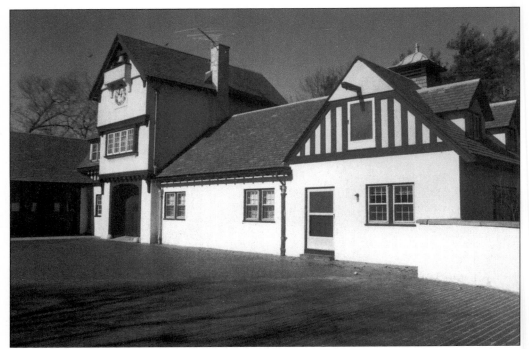

GREAT HILL STABLE-GARAGE. Mr. John Searles built the lodge and the foreman's residence, which are both shown as bordering the south side of Delano Road on the 1903 Marion map. The Jacobethan stables and garage complex was built c. 1910 from the designs of Chapman and Fraser.

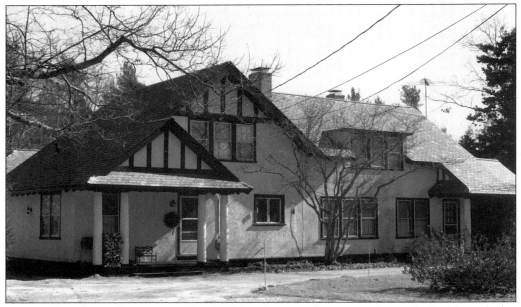

GREAT HILL STAFF RESIDENCE. The 1903 Marion map shows a road meandering through this large estate called Great Hill Drive. Located along the drive are the gardener's residence and the foreman's residence.

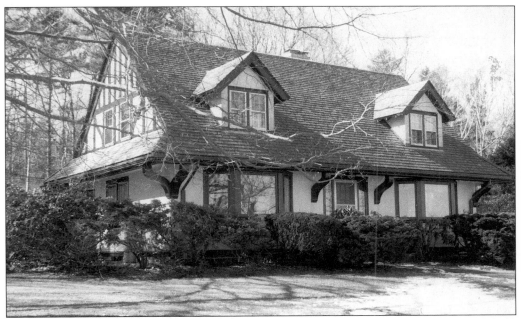

GREAT HILL STAFF RESIDENCE. The walls are stucco while its gables exhibit stucco and half-timbered surface treatments. The main facade's center entrance is flanked by side lights and sheltered by the deep overhang of the roof.

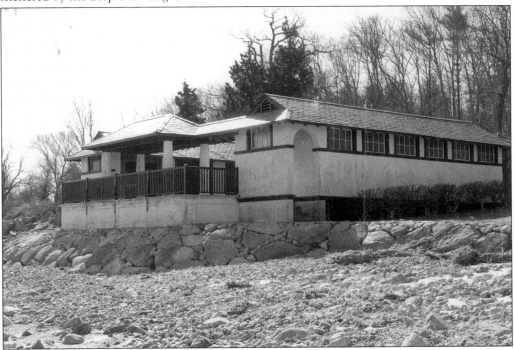

GREAT HILL BOAT HOUSE. Overlooking the mouth of the Weweantic River is the concrete, wood-trimmed, and gable-roofed boat house. Stylistically, this building exhibits characteristics of the Craftsman, Classical Revival, and Mission styles.

GREAT HILL GREENHOUSES. Seen above are some of the 23 greenhouses in which exotic Australian Acacia trees were grown. They bloom with yellow bell-type flowers.

GREAT HILL. This ancillary building at Great Hill exhibits the Jacobethan Revival style of architecture. Today, Great Hill continues to be owned by the descendants of Galen Stone.